War
LONDON'S

The Shelter Drawings
of Henry Moore

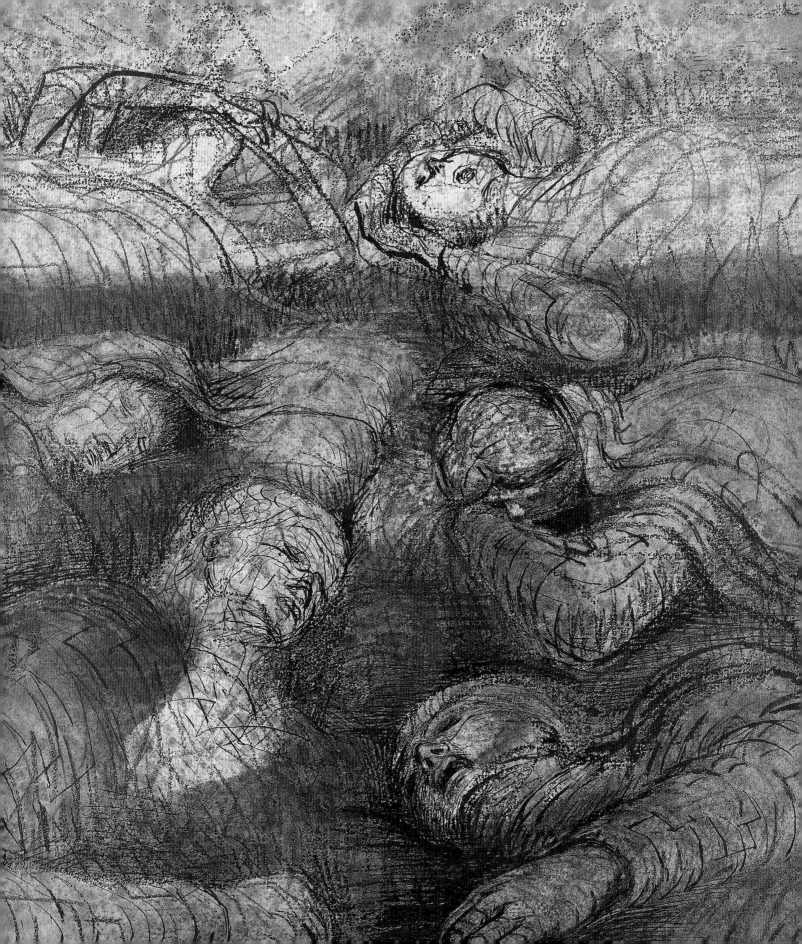

LONDON'S War The Shelter Drawings of Henry Moore

Julian Andrews

Lund Humphries

Contents

First published in 2002 by
Lund Humphries
Gower House
Croft Road
Aldershot
Hampshire GU11 3HR

and

131 Main Street
Burlington
VT 05401
USA

Lund Humphries is part of Ashgate Publishing

British Library Cataloguing-in-Publication Data
A catalogue record for this book is available from the British Library

ISBN 0 85331 844 1

Library of Congress Control Number: 2002100641

London's War: The Shelter Drawings of Henry Moore
© 2002 Lund Humphries
Text © Julian Andrews
Julian Andrews has asserted his right under the Copyright, Designs
and Patents Act, 1988, to be identified as the Author of this Work.

Designed by Tim Harvey
Printed in China by Compass Press Limited

Inside front and back covers: London burning from St Paul's
Cathedral 1940. Imperial War Museum. Ref. HU 36223

Frontispiece: Plate 65 (detail)

Acknowledgements

I should like to thank the Henry Moore Foundation and its Director, Tim Llewellyn, for their encouragement when I first put forward the idea for a book on the Shelter Drawings, and for the subsequent grant which has made this publication possible. Many other institutions and individuals have provided help and advice, but I owe a special debt of gratitude to three people: David Mitchinson, Head of Collections and Exhibitions at the Foundation, has been a friend and collaborator on Henry Moore exhibitions in different parts of the world over many years. I am deeply indebted to him for his support and enthusiasm for this project, as well as for the benefit of his encyclopedic knowledge of Moore's work. Frances Carey, Deputy Keeper of Prints and Drawings at the British Museum, was responsible for the wonderful exhibition of Shelter Drawings mounted at the Museum in 1988, which was an inspiration to me. It was the only occasion on which it has been possible to see the two complete surviving sketchbooks on display together, and I am deeply grateful to Frances for her generosity in sharing with me the results of her own research. Angela Weight, Keeper of Art at the Imperial War Museum, has been unsparing in putting the resources of her own department at my disposal. Her impeccable stewardship of one of the finest collections of Modern British Art in the country is of tremendous value to exhibition organisers, as well as being deeply appreciated by individual researchers.

Although this book can include only a third of Moore's total output of Shelter Drawings I am pleased to have been able to include reproductions of works from many regional and overseas museums and galleries, in addition to documentary photographs. My thanks, therefore, to the British Council; the Trustees of the British Museum; Hiroshima Museum of Art, Hiroshima; Hull City Museums and Art Galleries (Wilberforce House); Imperial War Museum; Leeds Museums and Galleries; The Museum of London; Manchester City Art Galleries; The Moore-Danowski Trust; Art Gallery of Ontario, Toronto; The Walter Hussey Bequest, Pallant House Gallery, Chichester; Royal Air Force Museum, Hendon; Robert and Lisa Sainsbury Collection, University of East Anglia, Norwich; Sheffield Galleries and Museums Trust, Sheffield; Trustees of the Tate Gallery, London; Fundación Colección Thyssen-Bornemisza, Madrid; London's Museum of Transport; Wakefield City Art Gallery, Wakefield; and Worthing Public Libraries. Also to those many private collectors who prefer to remain anonymous.

For special help I would like to thank Carole Callow of the Lee Miller Archive; Rosa Maria Letts of the Istituto Italiano di Cultura, London; Alex Marlow-Mann of the British Film Institute; Sebastian Cox of the RAF Historical Branch; Diana Eccles and Clive Philpot of the British Council; Malcolm Barr-Hamilton, Archivist, Tower Hamlets Local Studies Library; Winston G. Ramsey of After the Battle Publications, and Stephen Clarke of Clearwater Books.

Publication by the Henry Moore Foundation and Lund Humphries of volume 3 in the *Henry Moore Complete Drawings* series, covering the 1940s, came at an opportune moment. I am therefore grateful to Ann Garrould, the overall editor of this series, and to David Mitchinson and Angela Dyer who have wrestled with the task of cataloguing the Shelter Drawings. In addition, at the Foundation, I have been given invaluable support by Martin Davis, Information

Manager, and by Emma Stower, Photo Archivist, who have been kindness itself in tracking down materials. For other assistance with photographs I am grateful to Sasha Andrews and to Michel Muller.

Warmest thanks go to Michael Moody and the staff of the Department of Art at the Imperial War Museum. I was particularly pleased to be able to quote from Moore's letters to Arthur Sale, which are held in the Department's archives, and I am most grateful to Mrs Penny Sale for her encouragement and for information about her late husband. Also at the IWM, I was given valuable assistance, as always, by the staff of the Department of Photographs and the Department of Documents.

Others who have kindly provided help and advice include Roger Berthoud, Maurice Cardiff, Alexander Davis, Phil Eyre, Bernard Meadows, Martin Middlebrook, Martin Pollecoff and Alan Wilkinson, whose works on Moore's drawings are indispensable references.

It has been a pleasure to work with Lucy Clark, Alison Green and Lucy Myers at Lund Humphries, and I am especially grateful to Tim Harvey for his work on the design of this book.

Personal thanks go to my wife, Tricia, and daughter Rosanna for their patience during the months I was preoccupied with shelters and drawings. To conclude, I should like to dedicate this book to the memory of my parents, Frank and Josie Andrews, and to all those who were sheltering with us in Aldwych tube station in December 1940.

Julian Andrews

War
LONDON'S
The Shelter Drawings of Henry Moore

Note on the illustrations

The transparencies reproduced in this volume have been supplied by a number of different individuals and institutions over a period of time.

Note on the Shelter Sketchbooks

The First Shelter Sketchbook, consisting of sixty-seven pages, was given by Henry Moore to Jane, Lady Clark, who bequeathed it to the British Museum, where it is held in the Department of Prints and Drawings.

The Second Shelter Sketchbook, with ninety-five pages, was given by the artist to Irina Moore, who gave it to the Henry Moore Foundation, Perry Green, Herts.

Both sketchbooks were dismantled many years ago so that the pages could be mounted separately. The page size of the First Shelter Sketchbook is approximately 186 × 162 mm, that of the Second 204 × 165 mm.

Moore's works are referred to by their archive reference numbers: LH (Lund Humphries) for sculptures and HMF (Henry Moore Foundation) for drawings.

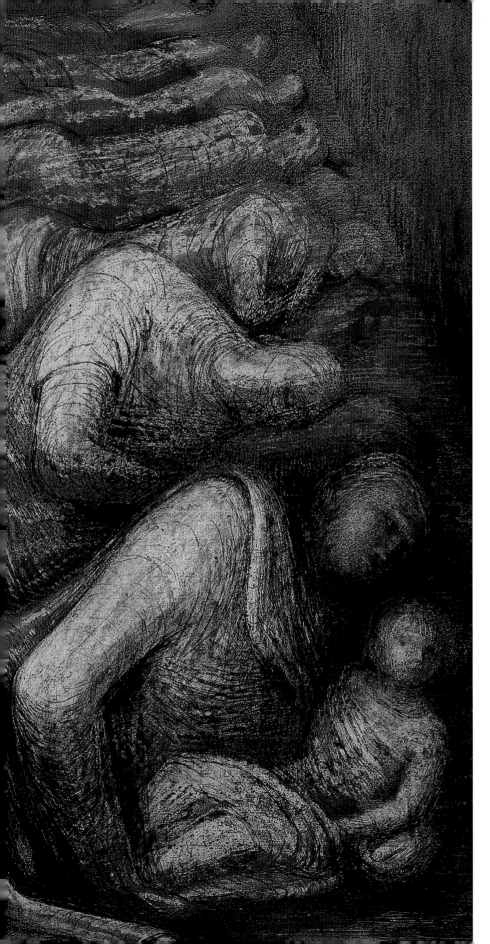

Introduction

Henry Moore's Shelter Drawings show human beings who have been caught up, unwittingly, in total warfare. They are not portraits of particular individuals, nor is there anything apart from the setting to indicate that these are Londoners, or even British. They are simply people: in Moore's words 'hundreds and hundreds of people who were having things done to them that they were quite powerless to resist.'[1]

It is the tragic universality of the experiences shown in these drawings which has given them a special quality, and which accounts for their continuing popularity. Nevertheless, by looking at the reasons why the London Blitz happened in the way it did, we can understand rather better the circumstances that led Moore to create these works.

The Shelter Drawings form a distinct body of work, separate not only from Moore's principal activity as a sculptor, but also from the rest of his substantial legacy of drawings and prints. These drawings were carried out over a relatively short, but intense period, from the autumn of 1940 to the summer of 1941. This burst of activity produced more than 300 drawings; roughly eighty in each of two separate sketchbooks which have survived almost complete (though now dismantled), together with a further eighty loose sheets from other sketchbooks, later taken apart so that the drawings could be sold separately. In addition Moore produced a number of larger drawings, usually squared-up versions of small sketchbook pages. Most of these were made at the request of the War Artists Advisory Committee (WAAC), who purchased thirty-one of the so-called finished works from him during the course of the war. These were subsequently distributed to the main

public museums and collections in Britain, where they can be seen today. A further group of works, on coal-mining subjects, was commissioned from Moore by the Committee later in the war, but they are not covered in this present study.

During his long working life Moore produced thousands of drawings. Several complete sketchbooks have survived covering specific projects (the *West Wind Relief Sketchbook* of 1928 for example), but no other group of drawings exists in his œuvre to compare with the shelter scenes. Right from the start they attracted widespread attention, and it was through these works that he became well known to the general public in Britain. They later attracted international attention, particularly in Germany and in the United States.

It is often assumed that Henry Moore began to draw scenes in the London Underground because he had been commissioned to do so by the WAAC. From this it is only a short step to the assumption that, from the start, these drawings were to some extent official art. In fact these impressions are false, though understandable. Moore began this series of drawings as a private exercise. In September 1940, on his discovery of the scenes in the tubes, the drawings were an expression of an inner need to come to terms with the changes brought about by the war. He felt strongly about the war and expressed his thoughts about it in letters to friends. But for several months he told nobody, apart from his wife Irina, that he was working on the Shelter Drawings.

When he showed Kenneth Clark a partially filled sketchbook in early December 1940, he probably didn't realise how suddenly and radically things would alter for him. Clark was excited by the

drawings. He saw that the shelter scenes had opened a new creative vein for Moore, and that they would attract a broader public interest. More than a year earlier, in his capacity as Chairman of the WAAC, Clark had failed to persuade Moore to become a salaried War Artist. Now Clark explained to him that he didn't need to sign up to the scheme on a contract, as Graham Sutherland and other artists had done, but he could sell some of his Shelter Drawings to the Committee, whose terms of reference were 'to record the war at home and abroad'.[2] Since the sketchbook pages were quite small the proposal – which Clark would ventriloquise through the Committee – was for Moore to make enlarged versions of several of them, to be sold to the WAAC for a set price.

In agreeing to this proposal, which was formalised in early January 1941, Moore was inadvertently signing a Faustian pact. The private nature of the project was at an end – the drawings would now become public property. This would be reinforced when the WAAC began including them in the exhibitions they were showing regularly in the empty rooms of the National Gallery. In addition, they were preparing special touring exhibitions of war paintings to be sent round regional museums and galleries – and even abroad. But there was another dimension to all this which only gradually became apparent to Moore: the identification of the drawings in people's minds with wartime propaganda.

Many claims have been made for the Shelter Drawings, some of them a little exaggerated. They are not all good drawings – in fact a few of them verge on the grotesque. But why not? After all, they

(opposite)
fig.1
Row of Sleepers (detail)
1941
HMF 1799
pencil, wax crayon, coloured crayon, chalk, watercolour, wash, pen and ink
545 × 320 mm
The British Council

were not originally meant to be exhibited, being more in the nature of personal visual notes, reminders of things seen, to be considered as subjects for future drawings or sculptures. While the argument that they materially affected the development of Moore's post-war sculpture can certainly be sustained, the fact that these drawings have inevitably been considered within the context of specific historical events has led to certain misreadings. Both the Battle of Britain and the Blitz – which was a continuation of that battle by other means – were also media events, and were seen and experienced as such even by those taking part in them. Radio commentaries, press reports and photographs, newsreel films (widely watched in all cinemas and in special 'News Theatres' at the main railway termini) bombarded the public with information about what was going on all round them. But information was filtered through the censorship departments of the Ministries of Information and Home Security and was therefore permeated by messages of propaganda and by exhortations aimed at maintaining the morale of the public. This propaganda barrage influenced public attitudes to the war for decades after it was over, through books, television programmes and jingoistic film interpretations of wartime events. At the time, and through much of the post-war period, people's perceptions of Moore's Shelter Drawings were coloured by these influences. References to Moore being a War Artist (not strictly correct) compounded an impression that the drawings had been produced as part of the propaganda effort, since it was known that the WAAC was run by the Ministry of Information.

Recent historians have convincingly shown that the events of 1940 were taking on the attributes of myth, even as they were happening.[3] One example is the enduring, but misleading, belief that the Battle of Britain was an uneven one, the Few against the many, when actually the two sides were very evenly matched.[4] While the Germans failed in their strategy, for the British the Battle was more an avoidance of defeat than a triumphant victory, though it is understandable why the authorities should have presented it as such. The myth of a united people standing firm against aggression is also revealed, when one remembers that even in late May 1940, after Dunkirk, the British Foreign Secretary, Lord Halifax, was still pressing for a peace settlement with Hitler.

For the British it has long been important to maintain and reinforce the myth of the island race, the people who had resisted the invasion of their land for almost a thousand years, who muddle through, losing battles, even campaigns, but who somehow contrive to win in the end. It was the fact that these comforting preconceptions were so nearly overturned in 1940 that led to the instantaneous creation of new myths. Moore's Shelter Drawings got caught up in this process while he was still producing them, but there was nothing he could do about it. Exhibitions of works by War Artists, particularly Paul Nash and Henry Moore, were being held up by respected critics as 'one of the most important events that has happened in British art for three-quarters of a century'[5] and 'equally potent as propaganda for our own generation or as records for generations to come'.[6]

Moore had lost his income from teaching when Chelsea and the other art colleges moved out of

London to escape the threat of bombing. Possibilities for sales of his sculptures had almost dried up and there seemed little chance of having exhibitions at commercial galleries in wartime. He was therefore facing financial problems, so his sales of Shelter Drawings to the WAAC in January 1941 came at a useful moment. The Committee bought four drawings for thirty-two guineas and offered to buy more, eventually acquiring thirty-one works from Moore by the end of the war. (Two of these were lost when a ship carrying an exhibition of works by War Artists to South America was sunk by a German U-boat.) The interest which the Shelter Drawings aroused amongst critics and the general public at all the venues where the WAAC exhibited did, in fact, lead to a great many private sales. Many of these were through the Leicester Galleries, who showed his work several times during the war. At least one American serviceman bought several Shelter Drawings while passing through London prior to the D-Day landings. Other sales were made to private collectors in the United States, following the success of Moore's first New York exhibition at Curt Valentin's gallery in 1943.

So the Shelter Drawings brought financial benefit, and with this came demands that he should do more of them. A number of his friends wanted to own examples, and this is one likely reason why there are so many versions of the *Tube Shelter Perspective* and the *Two Sleepers*, to mention just two of his best-known subjects. Later on, Moore often said the reason he gave up doing the Shelter Drawings was because the authorities were tidying up the tube stations and he no longer found them so interesting. But another reason was that he was becoming stale,

making too many versions of the same subject.

Almost all of Moore's statements about the Shelter Drawings, frequently quoted in books and catalogues, repeat the same things: the chance journey by Underground that led to his discovery of the shelters, his fascination with the improvised nature of the scenes and his loss of interest once the authorities started cleaning them up. But there is virtually nothing about his original motivation for undertaking what became an immense project, and then for sticking with it for so long. It is hard, from later comments, to get a sense of what his feelings were at the time. Perhaps the reason for this reticence was a certain self-consciousness, an awareness that his reasons for making the drawings had changed as he worked on them. He must also have felt a little equivocal about the fact that what had started out as a very private project, on which he had worked quietly, almost surreptitiously, had now become so public. In effect, the Shelter Drawings had assumed a personality of their own. Having worked for so many years to build a respectable position for himself as a sculptor, it must have been strange to find himself becoming known to a much wider public as 'the man who drew the Shelters'. This would explain why he was often so guarded in his comments about them, while the other factors mentioned have certainly affected the way people have read the drawings, over the years.

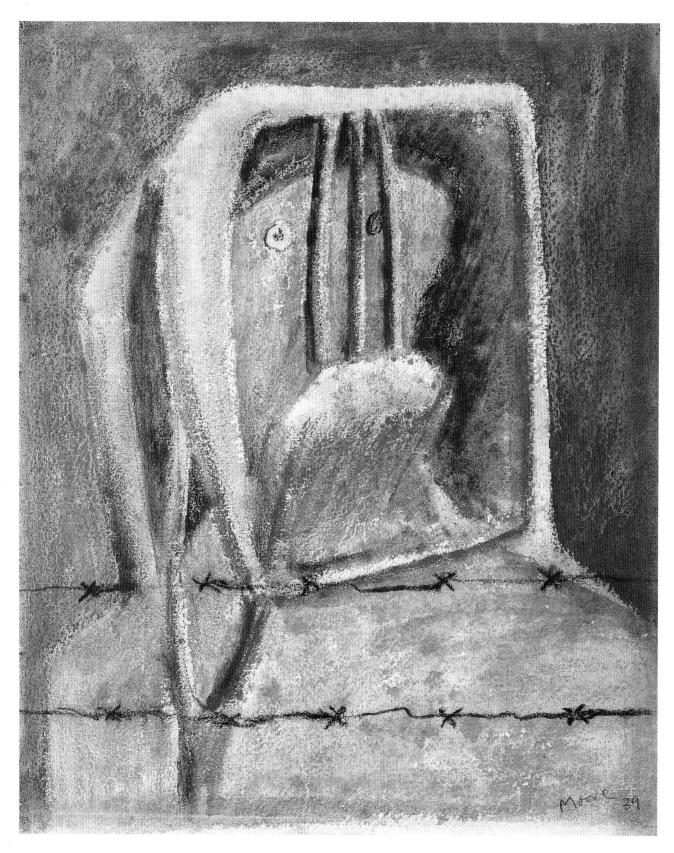

1

The 1930s and the Shadow of War

Moore was forty-one in July 1939, little more than a month before the outbreak of the Second World War. At this point he was consolidating his reputation as an important and innovative sculptor, within the somewhat limited world of British modern art. His name was also becoming known in wider international circles, mainly in France and Germany. His first sale of a work to a public museum – from his second one-man show at the Leicester Galleries in 1931 – had been to a German gallery, the Arts and Crafts Museum in Hamburg, though the piece subsequently disappeared during a Nazi cull of 'degenerate art' in 1937. However, it had been a long haul, the foundations being laid during his ten-year stint at the Royal College of Art from 1921 to 1931. For the remainder of the 1930s he had been able to combine the responsibilities of teaching two days a week at Chelsea College of Art with the freedom to develop his own work, first in his Hampstead studio and then, on a larger scale, at the cottage which he and his wife bought in Kent, in the south-east corner of England. These were prolific years, which produced many of his finest works; they were also the years which saw some of his most daring experiments in abstract work, pieces which were often influenced by his growing interest in Surrealism. In this he was in tune with a number of other artists of the period, particularly his friend and former colleague at the Royal College, Paul Nash.

Yet by no stretch of the imagination could the Moores have been described as 'well-off' at this time. Teaching paid the basic bills, but materials for sculpture had to be purchased, exhibitions were rare, and sales of works were limited to a few perceptive early patrons. On top of all this he had taken on a young student of sculpture, Bernard Meadows, as an assistant. By the outbreak of war in September 1939, Moore had accumulated a stock of works including a number of small sculptures in lead, as well as a considerable number of drawings which he used as sources for sculptural ideas. What he now urgently needed was to sell at least one major piece and the imminent prospect of war made this simultaneously less likely and more important for him, given that his teaching post would certainly come to an end with the outbreak of hostilities.

A deep, ingrained reticence was an integral part of Moore. It was there even when he was being friendly and sociable, welcoming an important museum director to his home, greeting a group of art students visiting his studio, or discussing his latest exhibition project with staff and colleagues. His slightly clipped, matter-of-fact comments could cut across a discussion and discourage chitchat. You invariably knew where you were with Moore. He was also known for the clarity and simplicity of his written statements, especially when describing his constant obsession with sculpture. According to his friend Arthur Sale, Moore's written style was admired by no less an authority than L. C. Knights, Professor of English at Cambridge.[7] Yet his writings, like many of his utterances, were often circumspect, carefully worded to make exactly the point he wanted without giving anything away.

When it came to political and social questions Moore made equally careful statements. During the 1930s many artists were drawn into groupings or movements which were not simply artistic, but which had broader concerns as well. Some aspects of modernism in art and architecture sat uneasily with

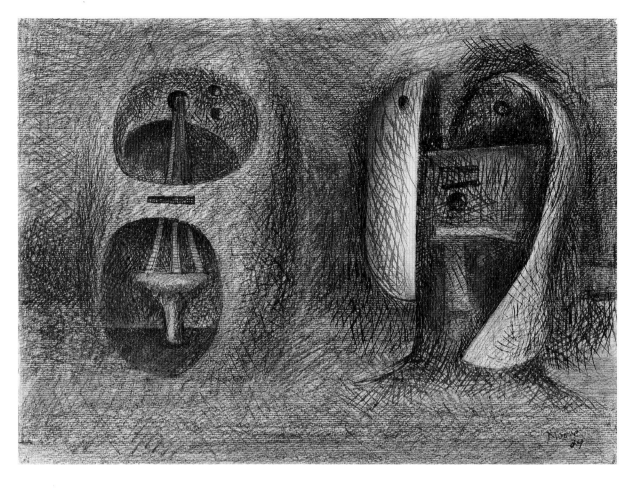

the growth of Fascism, forcing artists to take political positions and, on occasion, to make statements. With his customary caution, Moore was never an initiator of movements whether artistic or political, unlike his friends Ben Nicholson and Paul Nash. But he was a joiner, a supporter, very often a participant. The movement with which he was most actively involved was Surrealism. He was a member of the English organising committee for the International Surrealist Exhibition which opened in London on 11 June 1936, and still listed himself boldly as Surrealist in the issue of the *London Bulletin* for January–February 1939. (Ironically in this same issue Paul Nash, doyen of the English Surrealist movement, preferred to list himself as 'independent'.)

But Moore's name crops up in connection with the activities of all the main movements of the English art scene in the 1930s: Axis, the Seven-and-Five Group, Unit One, Circle, and the Artists International Association. Again and again, when reading lists of participants in exhibitions, one finds the summary ending with the words, 'and Henry Moore'. He had many friends among the left-wing intellectuals of the time, including the writer Stephen Spender and the physicist J. D. Bernal, known as 'Sage', a dedicated Communist and influential Marxist scientist. During this period Moore was an intermittent reader of the *News Chronicle*, being suspicious of the orthodoxies of *The Times* and the *Daily Telegraph*, but never committed himself fully to any political movement or creed.

With the outbreak of the Spanish Civil War in 1936 attitudes hardened and some artists and writers left to join the International Brigades in Spain. In 1938 Henry Moore was invited by the Republicans to visit Spain, as a member of a delegation that included Stephen Spender, the sculptor Jacob Epstein and the American singer Paul Robeson, but the trip had to be called off when the British Foreign Office refused to

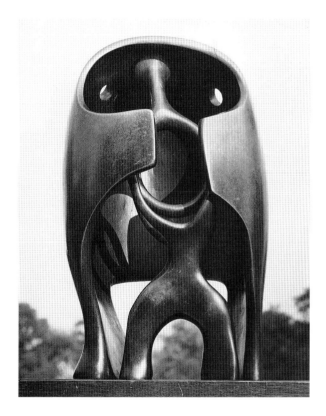

(fig.3), with its dark, hollowed-out spaces, disturbing in its sense of menace. This drawing relates directly to the sculpture in lead, *The Helmet* of 1939–40 (fig.4). The first of a number of versions of the subject that Moore would produce, it is an early example of his interest in the contrast of interior and exterior forms, here a small vulnerable figure being protected by a hard enveloping shell. Yet another sculpture from 1939–40, *Three Points* (fig.5), also expresses tension, the sense that a spark between the points could set off an explosion at any moment.

Similar anxieties of the time were reflected in the works of another artist, Paul Nash, with whom Moore shared many concerns. A sense of foreboding is often present in Nash, a feeling that something is about to happen. In the spring of 1939 he discovered 'Monster Field', a field containing several fallen trees, 'objects outside the plan of natural phenomena' in Nash's words, which 'had assumed, or acquired, the personality of monsters'.[8] He took

issue the party with travel permits. Not long after this Moore carried out work on a lithograph, *Spanish Prisoner*, which was intended to be sold to raise funds for the Republican cause. But before it was ready, news came of the fall of Madrid and then the end of the war, so apart from a few proofs it was never editioned.

This print, and the drawing from which it is taken (fig.2), is one of several works produced by Moore shortly before the outbreak of war which express a certain tension. Another example is the drawing *Drawing for Metal Sculpture: Two Heads* of 1939

fig.6
Monster Field
photograph by Paul
Nash
Tate, London

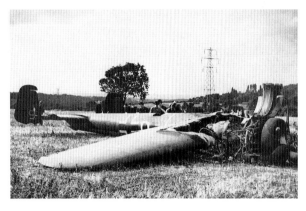

fig.7
**The Monster Destroyed
Crashed Dornier 17**
Imperial War Museum
Ref. HU70021

photographs of these trees (fig.6), from which he made several watercolours, and wrote an essay about his feelings on discovering the scene. There is an extraordinary resemblance between the photographs and drawings of these 'monsters' and the images of crashed German aircraft which Nash would later use as the basis for a series of drawings (fig.7). Nash was acutely aware that England could soon be suffering attacks from the air, so for him the looming German bombers were indeed monsters. In his watercolours of crashed Heinkels and Messerschmitts, which represent the physical destruction of the monster, Nash is also showing the symbolic destruction of evil.

Henry Moore was very aware of what Nash was doing. He also believed that war was evil, and that totalitarianism had to be fought by artists as well as by soldiers and airmen. He worried about how he could turn his work towards a useful wartime purpose, struggling to identify suitable subjects. During the Battle of Britain in that summer of 1940 he, too, made drawings of German aircraft.

Moore had taken an active part in the 1914–18

conflict, seeing frontline action at the Battle of Cambrai in 1917. But, by his own admission, he had been fortunate, having joined up like so many others in a spirit of naive bravado. From his training camp near Winchester with the Artists' Rifles he had written to his former art teacher, Alice Gostick, saying he expected to be getting embarkation leave shortly, 'and then when I come back here from leave, Heigh Ho! for France and a jolly old "blighty", fine time in hospital and then – the end of the war!!!'[9] Amazingly this was to prove an accurate forecast. His battalion was badly mauled during the German counter-attack at Cambrai, suffering high casualties. Moore's own company had to retreat from Bourlon Wood under a bombardment of gas shells. Moore caught sufficient of the gas to have to be invalided out (though fortunately it did not affect him permanently) and ended up in a convalescent hospital near Cardiff. When he had recovered he was sent back to France as a physical training instructor at one of the base camps, but not long afterwards the Armistice was signed.[10]

In 1940, however, he had no illusions, and in a letter written just as the so-called phoney war was coming to an end, he spoke about his former experiences:

> I was in the last two years of the last war. I joined when I was eighteen and was too young to know much. I just thought I was a hero and did my best to win medals. But a year or two after it the sight of khaki uniform began to mean everything in life that was wrong and wasteful, and anti-life – and I still have the same feeling.[11]

fig.8
September 3rd, 1939
1939
HMF 1551
pencil, wax crayon,
chalk, watercolour, pen
and ink
306 × 398 mm
The Moore Danowski
Trust

In one of his early written statements, 'The Sculptor Speaks', first printed in *The Listener* in August 1937, Moore opens with the comment that 'it is a mistake for a sculptor or painter to speak or write very often about his job'. In fact he made many formal statements about sculpture and gave many interviews, but tended to present a kind of set text from which he was unwilling to deviate. As his biographer, Roger Berthoud, ruefully observes, he had also worked out a kind of edited version of his life so as to avoid the strain of countless interviews. Where one does get closer to his feelings is in his letters – though unfortunately he hated letter-writing and not many have been collected so far. But a few letters to his friend Arthur Sale, which have recently been deposited in the archives of the Imperial War Museum, do provide some insights, particularly to his political attitudes and his feelings about the war.

Arthur Sale was a teacher and lecturer, who also wrote poetry. He had been invited by Herbert Read to contribute some verses to an exhibition of Surrealist Objects and Poems at the London Gallery. When he and his wife went to visit the exhibition they were introduced to Moore by Roland Penrose, one of the organisers. A friendship developed which was maintained over a number of years even though, by their own admission, Sale and his wife knew very little about modern art. This was, perhaps, one reason why Moore felt at ease with Sale and why he felt able to write to him quite freely – he was not part of the art world with its internal politics and factions in which Moore spent so much of his time. Arthur Sale was also a pacifist and a registered conscientious objector, an attitude which Moore respected and which interested him during this period when everyone seemed obsessed with war. His discussions and correspondence with Sale seem

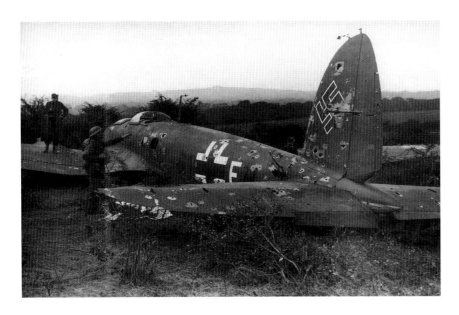

fig.9
Heinkel shot down at
High Salvington
19 August 1940
The Worthing Gazette
After the Battle
Publications

to have forced him to try to define his own attitudes to the issues. Some of his thoughts are expressed in a short paper he wrote, headed 'Artists and Politics'. It is not dated but was probably written sometime in the late 1930s, at the latest early 1940. In it he set out his view that it was no longer possible for anyone to remain indifferent to current events and that artists, together with scientists and writers, had to be prepared to stand up for intellectual freedom in the face of the threat of dictatorship: 'This freedom we have gained by the continuous struggles of past generations. Every attempt at the curtailment of freedom of ideas must be fought by us all.' He expressed similar views in a letter to Kenneth Clark dated 1 October 1939, a month after the outbreak of war:

> before long the war atmosphere might get closer
> and so intense that to keep the state of mind for
> working won't be possible, & so there'd be nothing
> for it but to seek actively a way of taking part in it.
> For I hate intensely all that Fascism and Nazism
> stands for, & if it should win it might be the end in
> Europe of all the painting, sculpture, music,
> architecture, literature which we all believe in.

After the radio broadcast on 3 September in which Neville Chamberlain broke the news that Britain was at war with Germany. Moore and Irina, together with Bernard Meadows, got into their car, drove to the coast near Dover and went for a swim below the Shakespeare cliffs. Moore afterwards recorded his feelings about this moment in a powerful drawing, which he called *September 3rd, 1939* (fig.8). In it a group of female bathers, their heads like gas masks, stand in the water with their backs to the English cliffs, gazing apprehensively out to sea in anticipation of the threat from across the Channel.

Once the moment had passed a curious sense of anticlimax took over, as month after month of the phoney war went by with little or no sign of conflict, at least in the quiet Kent countryside. Teaching at Chelsea was suspended for the autumn term, but Moore continued to work at a major sculpture in elmwood, together with a number of smaller pieces in lead and a number of drawings, in preparation for a long-planned exhibition at the Leicester Galleries. The show duly went ahead in February 1940 in spite of the war situation and a bitter winter. The promised air raids had not materialised, apart from a few incursions by German aircraft testing the British defences, and people seemed more concerned with the inconveniences of the blackout and the tightening screw of food rationing. Then, in early May, came the German invasion of Belgium and Holland, and within a week, France. Even as the British Expeditionary Force (BEF) and the French armies began their retreat towards the Channel, preparations to meet an air attack on Britain, as a prelude to a seaborne invasion, were being put hastily into effect.

In spite of this threat, for the first months of 1940 Moore was able to continue his regular pattern of life. Chelsea had reopened in the New Year, and Moore went up to London every Tuesday and Friday

fig.10
Plane Crash in Sussex:
Summer 1940 (detail)
1940
HMF 1552a
pencil, wax crayon,
coloured crayon,
watercolour wash
191 × 276 mm
Imperial War Museum
Ref. IWM ART 16112

to fulfil his teaching commitments. 'For financial reasons I'm very glad my Chelsea teaching has started again – it'll stop, of course, immediately there's any bomb scare!' But he found London much altered: '... expect I shall get used to the depressing, sordid atmosphere ... I've looked forward to seeing certain of my friends who've remained in London and I've not seen since the war began. But those I've seen so far seem dulled and deadened, and meeting them again falls short of what I was expecting.' In the

same letter he went on to elaborate on his feelings about the war which he had sketched out in his 'Artists and Politics' statement: 'I hate the war! Apart from its most terrible side, all the maiming and killing it's going to bring, it blinds people to all the real values in life, holds back the progress of all those activities in life one believes worth while.... I'm still in the process of trying to get my attitude to the war clear and satisfactory, even to myself.'[12] One can deduce from parts of this letter that Arthur Sale, to whom he was writing, had expressed strong doubts about the Chamberlain Government. Moore made no bones about his own feelings on the same subject: 'I still think the war could have been avoided if we'd had a government less terrified of socialism and more sympathetic and ready to work with Russia. The Chamberlain Government I think is the worst in our history, it helped rear the Hitler Germany.'

In May and June of 1940 events moved swiftly, with the ignominious withdrawal of the British army from Dunkirk, leaving behind almost all its *matériel*, and the capitulation of France on 22 June. Moore realised he had to find himself useful employment and, together with his friend Graham Sutherland,

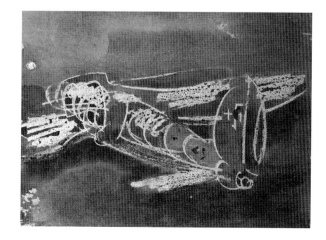

fig.11
War Drawing:
Aeroplanes (detail) 1940
HMF 1552
pencil, wax crayon,
charcoal (rubbed),
watercolour wash
190 × 277 mm
The Henry Moore
Foundation

applied for a place on a precision tool-making course at Chelsea Polytechnic. But the weeks passed and they heard nothing. As it turned out there had been too many applications and they were not needed.

This was the moment when the Moores finally had to give up their cottage near Canterbury, since it lay in the area where invasion was most likely. They retreated to London, where they took over 7 Mall Studios in Hampstead from Ben Nicholson and Barbara Hepworth, who had moved down to Cornwall. The studio space was large enough for Moore to set out a number of his medium-sized figures in plaster and in stone, and there was living accommodation above. But, as it turned out, they did not stay there very long.

It is clear that the problem of finding suitable war subjects kept nagging at him. Several 1939/1940 drawings have scribbled notes on the back about searchlights, bombing and other war topics. During that summer he began making drawings of crashed German aircraft. It is interesting to see how his version of a shot-down Heinkel 111 differs from a Paul Nash interpretation of the same subject.

The Heinkel drawn by Moore was shot down at High Salvington, near Worthing in Sussex, on 16 August 1940 (fig.9). His former art teacher, Alice Gostick, who lived in this village almost certainly sent him a cutting from the *Worthing Gazette* which printed photographs of the incident a few days later (such images had to be approved by censors before

fig.12
Crashed Heinkel 111
Royal Air Force Museum,
Hendon
Ref. P2209

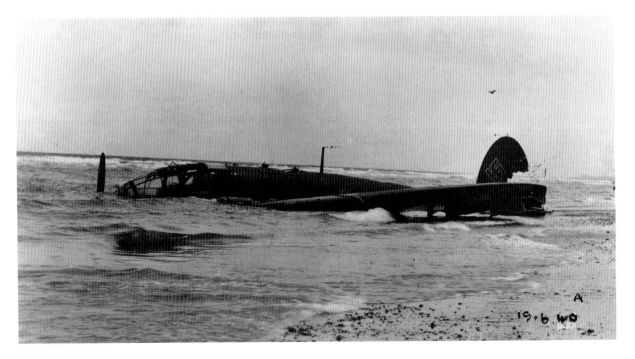

fig.13
Paul Nash
Dead March Dymchurch
1940
chalk and watercolour
394 × 572 mm
destroyed by enemy
action in 1942
Imperial War Museum
Ref. LD 819

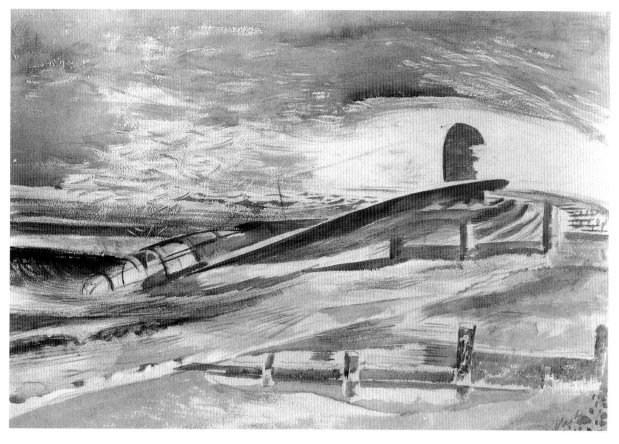

publication and only images of German aircraft could be shown – crashed Spitfires and Hurricanes never appeared).

With its gull-wing shape, its cockpit flush with the curve of the fuselage and its rakish tail, the Heinkel 111 was an elegant aircraft, attractive in a slightly sinister way. Moore's drawings are a precise parallel to the photograph (one of them even showing the lines of the hedges in the background) (fig.10) but clearly what interested him was the solidity of the object, especially the dominant tail (fig.11). He was looking at it as a sculptural shape. For Nash however all planes had personalities of their own and his Heinkel (which crashed on the Norfolk coast on 19 June 1940) has the soft, drooping form of a dead bird, a seagull perhaps, with the sad sense of a creature that has lost its power of flight (figs 12–13).

Moore's aircraft appears in several more drawings, including the beautiful *Eighteen Ideas for War Drawings* (pl.1), and in several early pages of the First Shelter Sketchbook, but he wisely decided not to pursue it as a subject. Exactly when the

Eighteen Ideas for War Drawings were drawn is not certain. It may well have been in August or early September 1940, after the aircraft drawings but before he discovered the tube shelters. Alternatively the sheet may date from later that autumn, when the shelter scenes were well under way. A number of the titles written neatly above each tiny scene also appear in the inscription which fills more than half of page 45 of the First Shelter Sketchbook, headed *War: Possible Subjects* (pl.2). Phrases like 'Contrast of opposites' and 'Contrast of peaceful, normal, with sudden devastation' are indicative of his concerns, particularly with the effects of the devastation of war on civilians. Three of the tiny drawings in the top row are of searchlights sweeping the skies, a sight that had become familiar to Londoners during the First World War, when Zeppelins were overhead. Many artists had drawn this subject and it is possible that Moore picked up this idea from other images he had seen. If the *Eighteen Ideas for War Drawings* were drawn in the summer of 1940, this was before the night raids had begun.

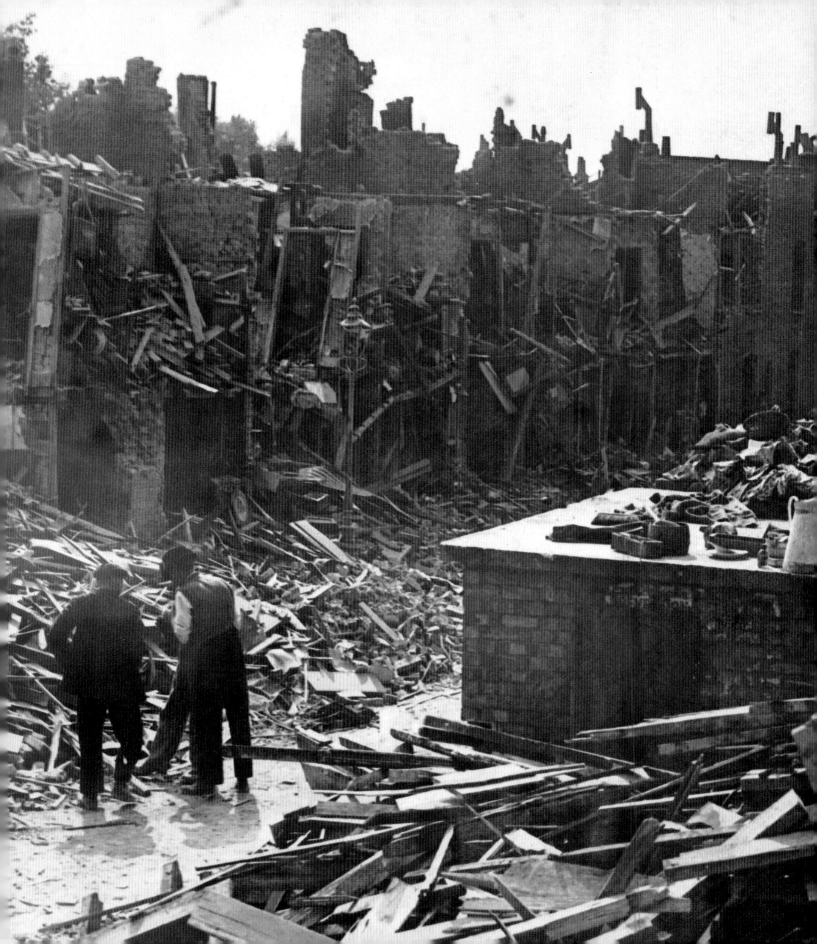

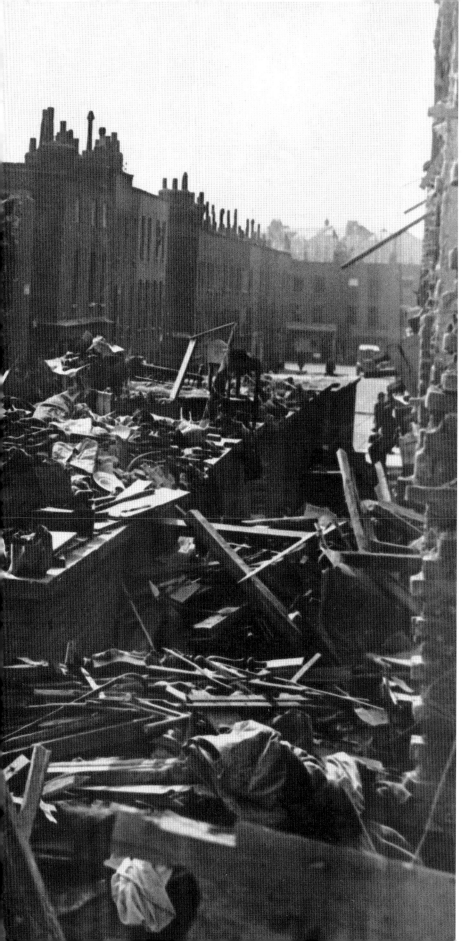

Defence and Protection

As the international situation worsened through the late 1930s, the authorities in Britain became increasingly preoccupied with the problem of how to protect people from air raids. Britain's first line of defence was its chain of radar stations along the coast, alerting the pilots of Fighter Command to the approach of attackers. But it was always recognised that enemy aircraft were bound to get through. How many attackers there would be? What proportion of them would reach their targets? What kinds of bombs they would carry, and what damage would these cause? These were all totally unknown factors. Almost as uncertain were what the effects of concentrated bombing would be on the morale of the civilian population, though some knowledge had been gained from the experience of the Spanish Civil War.

The second line of defence would be batteries of anti-aircraft guns, supported by searchlights. These would be placed in a protective screen around key industrial targets, such as aircraft and munitions factories, ports and military installations, and around major population centres, including London. The state of these defences at the start of the war was, quite simply, appalling. While the science of anti-aircraft gunnery had certainly developed from its rudimentary beginnings in the First World War, this branch of artillery had always been something of a Cinderella. Funding for the production of heavy anti-aircraft guns had been inadequate, priority being given to other types of weapon. The small reserves of guns that did exist were regularly plundered for other uses by garrisons in various parts of the Empire. There were disagreements between the various armed services as to who should have responsibility

(previous page)
fig.14
Surface shelters in a
bombed street
Imperial War Museum
Ref. HU 634

for which aspects of anti-aircraft warfare, and even after the setting-up of a unified Anti-Aircraft Command in April 1939 the arguments continued. The Royal Navy, in particular, was being unreasonable. For the protection of the naval base at Rosyth, in Scotland, it demanded ninety-six guns, while only four were given to RAF Headquarters at Stanmore which was responsible for directing all Fighter Command stations involved in the Battle of Britain. Finally, many anti-aircraft guns had been left behind in France when the BEF was evacuated from Dunkirk.

Manpower was an even worse problem, since few men and women were interested in applying for a branch of the armed services which was clearly being given low priority. In his unusually frank memoirs the former Commander-in-Chief of AA Command, General Frederick Pile, pointed out the difficulties caused by the fact that his units were being given the leavings of the army after every other branch of the Services had had their pick:

> The men had passed through recruiting centres where they had had extensive medical examinations, but many of them were quite unsuited to any military duty, let alone the highly technical duties of AA. Out of twenty-five who arrived at a fairly representative battery, one had a withered arm, one was mentally deficient, one had no thumbs, one had a glass eye which fell out whenever he doubled to the guns, and two were in the advanced and most obvious stages of venereal disease. This percentage was a fairly common one.[13]

The poor state of the anti-aircraft defences in the London region led to the need for drastic measures when the Luftwaffe switched its attacks from Fighter Command airfields and sector stations to a systematic bombardment of the capital. In an odd way this was to have a direct effect on Henry Moore, leading to his discovery of the Underground shelters and his decision to embark on the Shelter Drawings.

The third line of protection would be systems of shelters. In 1938 the ARP (Air Raid Precautions) Committee, which had been in existence since 1924, made public its plans for the construction of public shelters 'giving protection against blast and splinters'. It also issued copies of a booklet, *The Protection of your Home against Air Raids*, to every household in the country. Three kinds of shelter were envisaged. The first was a small shelter called the Anderson, named after the engineer who designed it, Dr David Anderson. It usually held no more than six persons, and was made of prefabricated sections dug into the ground, with a curved roof protected by a thick layer of earth or sandbags. These shelters were designed to be installed by householders themselves. The government undertook to supply such shelters free of charge to anyone earning less than £250 a year, and had actually delivered one-and-a-half million of them by the outbreak of war, providing shelter for an estimated six million people. They also encouraged others to buy Andersons for prices ranging from £6 to £10, depending on the size. These shelters were perfect for houses with gardens, and proved extremely effective when the raids began, withstanding the blast from a 250kg bomb falling as close as fifty feet away, and resisting the collapse of debris and rubble from buildings

suffering direct hits. But they were quite unsuitable for areas where housing consisted of long terraced streets, or council-owned tenement blocks. Inevitably, working-class districts close to docks, factories or other centres of industry contained a high proportion of such housing, nowhere more so than the East End of London. A considerable effort was therefore made to design and build suitable surface shelters of brick and concrete which could accommodate as many as fifty or sixty people, and which would stand in the middle of a street (fig.14). The advantage of this system was that the shelters could be built fairly quickly, and there was also a better chance of achieving the target time of five to seven-and-a-half minutes to reach the shelter after hearing the warning siren.

It was this time factor which was used by the government as one argument against the policy of constructing 'deep shelters', a controversial issue which stirred up strong feelings and arguments in the months before war broke out. Those who remembered the way huge numbers of people had flocked into the London tube during Zeppelin raids in the First World War, had argued for a programme of 'deep shelter' construction, and this point was taken up by many left-wing organisations, including the British Communist Party. It has often been said that the reason a 'deep shelter' programme did not go ahead at this time was that the authorities were afraid of encouraging a so-called 'shelter mentality'. Once people were encouraged to go underground, it was suggested they might be unwilling to come up again, so causing heavy losses to industrial production through increased absences from work. While this view certainly existed in some quarters,

this was not why the 'deep shelter' policy was rejected. The reasons were practical – deep tunnel constuction would take at least two years, whereas raids were expected imminently – and also political: since it would only be possible to construct deep tunnel shelters in a few places, this would run counter to the declared policy of equality of shelter provision for all classes of people and in all areas where raids were expected. However, where natural features existed which were suitable for conversion into deep shelters, the government encouraged local authorities to make use of them. Thus, tunnel shelters were dug into cliffs in several places, including Ramsgate and Dover, while the system of natural caves at Chiselhurst in Kent, previously used for mushroom farming, was converted into a shelter for thousands of people, equipped with bunks and electricity.

The basements of large buildings constructed by the steel frame method were also declared suitable for conversion into shelters, though warnings were issued (not always followed) about the dangers of assuming any basement was safe, simply because it was below ground level. The risks of being buried by rubble from a direct hit on the building were considerable, and many tragic events of this kind did happen when the bombing began. Steel-framed buildings, however, proved remarkably resilient, even to the impact of a 250kg bomb, the famous Tilbury shelter in the Commercial Road, Whitechapel, described in detail later, being one such building. However, the government passed a special regulation forbidding the owners of pubs to convert their beer cellars into shelters, presumably fearing that the patrons might never emerge!

By far the highest proportion of people simply stayed put and remained in their homes, clearly believing the chances of their particular building being hit by a bomb were statistically very low. In this they were perfectly correct, though the experience of being in an ordinary terrace house, sheltering in the cellar or under the stairs perhaps, could be quite harrowing in the middle of a heavy raid with bombs falling close by. Recognising that this was likely to happen, in May 1940 the government produced a further booklet called *Your Home as an Air Raid Shelter* which encouraged people to take quite simple measures to create a 'refuge room' within their home, strong enough to protect them against falling rubble, and most damage apart from a direct hit. The issue of the Morrison shelter – a kind of metal-framed table underneath which a person was protected by steel mesh – began in March 1941 when the Blitz was still at its height, some 400,000 being approved initially for free distribution (they could be bought for £7 by those who were above the new income limit of £350 a year).

But in London, at the start of the war, the big question had still not been answered: what policy should the authorities adopt over the tubes? The proponents of 'deep shelter' policy clearly saw the entire London Underground system as suitable for immediate takeover as shelters, as did the Communist Party. The government view was that it was essential to keep the system running as normally as possible throughout air raids, in the interests of maintaining efficient communication across London. The fear was that pressure from huge numbers of people invading the tubes might force the staff to stop the trains. But it was recognised,

also, that there could be no method by which station staff could distinguish between genuine travellers and people who had simply bought a ticket to gain admission to the platforms and who then could not be moved on. Unwilling to announce measures that could look as though they were discriminating against certain classes of people, the government took no formal decision, and events took their own inevitable course.

Passengers emerging from Borough Underground Station, between Waterloo and London Bridge, who turn left towards the new Globe theatre and Tate Modern may easily ignore a small metal plaque fixed to the wall. The wording on it explains that it was here that the world's first underground electric railway was opened in 1890. This was the first deep tunnel 'tube' to be constructed, and the first purpose-built railway tunnel to be driven under the Thames. In 1891 it was used by over five million passengers. The plaque goes on to say that a tube spur below the station was used as an air raid shelter for up to 14,000 people during the Second World War. Borough was one of many Underground stations used for this purpose, as it had been in later stages of the First World War. During the most intense phase of the London Blitz, through the autumn and winter of 1940–1, an average of 100,000 Londoners found shelter in the tubes each night. A new and extraordinary world came into existence down in the tunnels, a world which attracted the interest of many artists and photographers, including Henry Moore. But this only happened because of a combination of factors: the size and extent of London, the existence of the Underground network and the fact that the German aircraft and the bombs they were using

could not destroy or even penetrate this system to any extent. For other British cities attacked repeatedly by the Luftwaffe it was another story: in terms of intensity of bombing over a particular area and overall percentages of buildings destroyed, Coventry, Southampton, Plymouth and Merseyside all suffered worse than London. If the Germans had had aircraft and bombs similar to those available to RAF Bomber Command later in the war, things would have been very different.

London's war was therefore a war of survival, and the Shelter Drawings of Henry Moore record that survival.

3

The Battle of London

During the summer months of 1940 the Moores stayed at the Hampstead studio and tried to continue a relatively normal life. High above, fine silver vapour trails and an occasional faint rattle, like the sound of a stick run along railings, revealed the existence of an extraordinary struggle otherwise invisible in the capital. The Battle of Britain, in which two air forces were fighting for control of the skies over southern Britain, was reaching its height. All across the southern and eastern counties aircraft wreckage lay strewn in tangled heaps, while on both sides the toll of dead pilots rose. The population of London watched nervously the progress of German air raids, which were steadily encroaching on their city. At first the Luftwaffe had launched its attacks against merchant-shipping convoys in the English Channel, and on ports such as Dover, Portsmouth and Weymouth. It then switched to concentrate on the Fighter Command airfields scattered across the Home Counties and eastern England, then moved up to bomb the Group Sector Stations, closer to London. These were the nerve centres of the British defence, controlling all communications between the radar stations, the fighters and the anti-aircraft defences. The Luftwaffe's aim throughout these initial stages was to neutralise the RAF and clear the way for a seaborne invasion of southern England. But during these same weeks, between late July and the beginning of September, bombing raids were made on cities in the south-west of England and in Wales, exercises in testing British defences which inadvertently also gave valuable experience to the defenders.

Heavy night raids on Bristol, Liverpool, Birmingham and other industrial cities followed, the start of a systematic attempt to destroy British war production. Then, in the middle of August, bombs began to fall on London. Southern districts were hit first, including Croydon, Wimbledon and New Malden, but central London was bombed on the night of 22–3 August. Many raids followed on succeeding nights, causing damage to northern districts such as Harrow, Uxbridge and Finchley, as well as to Croydon, again, and the suburbs in the south-east of the city. Londoners began to get used to listening for the warning sirens, and started to equip their shelters with basic comforts to help them through the hours they would spend huddled together. Increasingly, groups of people, carrying bags and bundles of improvised bedding, began to collect in the streets outside the entrances to Underground stations, ready to get below when the siren sounded. Henry Moore began to notice these groups forming in the late afternoons (fig.15).

What became known as the Battle of London opened on Saturday 7 September. During that afternoon observers manning radar screens and the Controllers in the sector stations noticed a steady build-up of German aircraft across the Channel, in several different groups. At first there was nothing to show that this would be any different from previous occasions when a number of separate targets in southern England and the London area had been attacked simultaneously, defensive fighter squadrons being scrambled accordingly. But, in fact, the separate streams of bombers all began to converge on one area, and by five o'clock in the afternoon the biggest aerial armada so far assembled, 345 bombers supported by 617 fighters, was moving up the Thames estuary to the docks and

fig.15
Edward Ardizzone
Waiting to go into the tube (detail) 1940
watercolour
510 × 705 mm
Imperial War Museum
Ref. LD 875

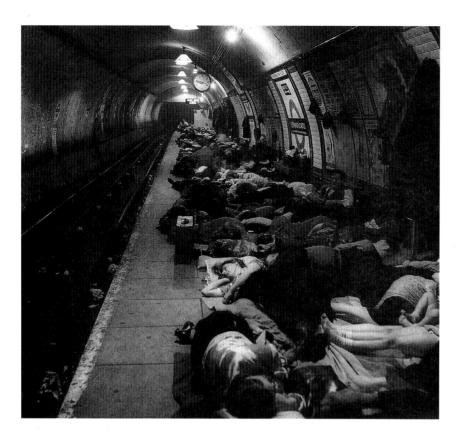

fig.16
Elephant and Castle
tube station by night
1940
Imperial War Museum
Ref. D1568

the Port of London. With Fighter Command caught partially off-guard, their aircraft still patrolling airfields and sector stations, the German bomber crews had a virtually unopposed run. Wave after wave of aircraft dropped their bombs in conditions of clear visibility, encountering very little anti-aircraft fire. Enormous damage was caused, and the pall of black smoke rising from the docks was soon visible all over London. But it became apparent that London had only seen the first phase of this attack. A series of night raids began after dark, with a further 250 bombers finding their way to the same targets by the light of the fires started earlier. The Germans were using the technique of mixing incendiary canisters with high explosive bombs. This ensured that fires started by small bunches of incendiaries, which might otherwise have been dealt with easily by the fire brigades, quickly increased to become conflagrations by the use of relatively small (50kg or 100kg) high explosive bombs, dropped directly onto buildings already burning.

Official figures given by the Fire Services after the 7 September raid were that it caused nine

conflagrations, fifty-seven large fires and nearly 1000 smaller fires. Four hundred and thirty people were killed in the first raid, and a further 412 on the following night. This was the start of what became known as the Big Blitz which would continue with very little interruption until the end of May 1941. In the first stage, the Battle of London, the capital was bombed for fifty-seven nights in succession by an average of 160 aircraft, each carrying a ton of high explosive and incendiaries. On the night of 18–19 September no less then 350 tons of bombs were dropped on London, more than the overall weight dropped on the United Kingdom during the whole of the First World War. Damage to industrial production was less than originally expected, but the civilian population suffered severely, nearly 10,000 people losing their lives from the bombing during these first two months alone. The bombing then continued intermittently, raids on the capital alternating with attacks on other cities, but London still suffered exceptionally severely, notably in December 1940 and in May 1941.

T. H. O'Brien, author of 'Civil Defence', the volume of the *Official History of the Second World War* which covers the Blitz, states that the most serious problem for passive defence was shelters and sheltering: 'The raids produced an immediate desire on the part of a not insignificant part of the London public to go underground to shelter.'[14] In certain areas, where tube stations were available, the public poured into them, taking no notice of the widely published announcements that they should not be seen as shelters. Many of these people remembered using the tube in this way during the First World War, some twenty-two years earlier. What was different was that

fig.17
Sleepers in the tube
Imperial War Museum
Ref. D1685

while raids in the 1914–18 conflict lasted a relatively short time, in 1940 the waves of Heinkels and Dorniers continued to roll in, one after the other, all night long – and to repeat this night after night. It was a deliberate part of German bombing policy to try to disrupt the sleep of Londoners, as part of the overall strategy of lowering morale. The Germans hoped this would cause a decline in industrial production and increase the likelihood that the people would force their leaders to sue for peace. This pattern of repeated night raids had not been foreseen by the authorities, one immediate consequence being that shelters were not being used simply for a few hours at a time. They now had to become dormitories.

What did it feel like to be living through these raids? For those families who had retreated to Anderson shelters, or were huddled under the stairs in their own homes, the sound and physical shock of bombs exploding nearby was intense. However, people quickly got used to it, especially as they learned to distinguish between different types of explosion and to estimate the distance away that a bomb had fallen. In some ways the noise of a building collapsing nearby was worse than an explosion, which seemed to be over as soon as it happened. For those in basement shelters under large buildings, bombs falling close by were *felt* more than heard. The whole space would jolt with a heavy concussion that sometimes caused momentary deafness, while plaster dust would fall in streams from the roof or ceiling, covering the shelter occupants in fine white powder and gritty sand. There was also a greater sense of claustrophobia in basement shelters, a fear that one might become

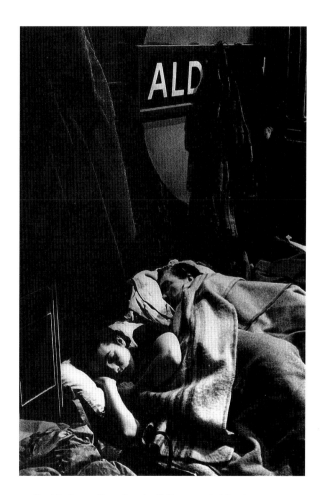

walled in by collapsing buildings outside. In an Anderson, with really no protection against a direct hit, comfort could still be gained from the fact that one was close to the outside, some families preferring to leave the door open so that they could see the night sky, even at the height of a raid.

The tube stations were different. More than sixty feet below London, down on the platforms of the

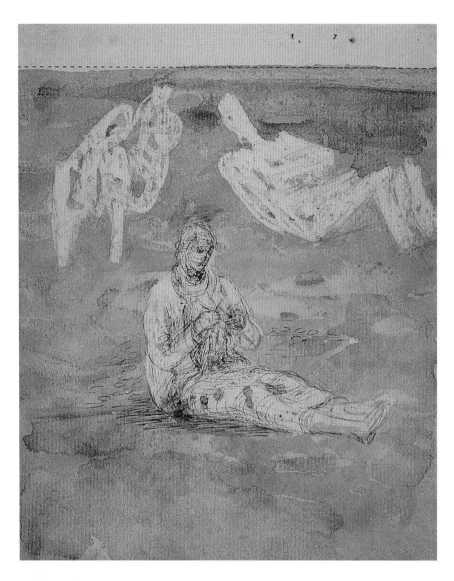

fig.18
Seated Woman Knitting
1940–41
HMF 1581
pencil, wax crayon,
watercolour wash, pen
and ink
First Shelter Sketchbook
p.23
The British Museum

deep levels, there was no sensation at all of a raid taking place, no noise, no vibration or concussion. It was a strange subterranean world with dull lighting and a heavy atmosphere, which at times gave people the sensation of living in an aquarium (fig.16). The air was thick and the platforms, on which people spread coats and blankets to stake out spaces, were hard and uncomfortable, bare concrete covered in a thin film of grit. Attempts to find a more comfortable position were painful on knees and elbows, while bags or folded coats had to make do as headrests until, realising the raids were going to be a nightly event, regular shelterers began bringing their own cushions and pillows (fig.17). Sanitary facilities were minimal, in many stations being limited to buckets

behind a hessian screen, but the staff of London Transport worked wonders to make their stations not only habitable, but friendly places. Above all they were warm, and there was a strong sense of companionship. Despite the discomfort and the total lack of privacy, people learned to adapt, and found they were able to get some sleep – certainly more than if they had stayed in surface shelters or Andersons (figs 18–19).

In all but a very few stations – Aldwych, for example – rail services continued, the distant approach of a train being announced by a blast of warm fetid air pushed down the tunnel from the previous stations. Normal night-time services were maintained as far as possible on the deeper lines, such as the Central, the Piccadilly and the Bakerloo. But some sections of line running under the Thames were closed off. The fear was that a bomb falling into the river might penetrate the tube tunnels which sometimes run surprisingly close beneath the river-bed. Special floodgates were installed on a number of lines, but fortunately no serious flooding incidents occurred in the centre of London. As the voluntary services began to get organised, simple first aid and nursing facilities appeared in a number of stations. Trains carrying canteens with supplies of tea and cocoa moved along the lines late at night, stopping at all stations to provide basic but badly needed refreshments for exhausted shelterers, many of whom had been bombed out of their own homes.

Unfortunately, not long after the heavy raids began, it became apparent that a number of the specially built surface shelters were suffering from defects. Since the outbreak of war cement had been in short supply, as a result of increased demand for

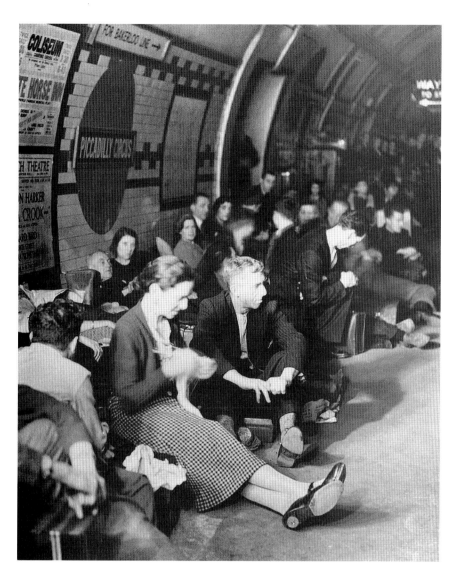

fig.19
Woman knitting
London's Transport
Museum

military purposes. To try and stretch existing supplies further, instructions had been issued advising local authorities to dilute the sand-and-cement mixture they were using as mortar in the construction of shelters and to add a proportion of lime. Too late it was realised that the wording of these instructions had been somewhat ambiguous, so that in certain districts lime had been used as a replacement for the cement. Several shelters began to show signs of cracking as a result of concussion from nearby bombs. Word of this quickly got round, with the result that local people shunned these shelters, preferring to find strong basements or, if they were near enough, to get down into the tube.

Such incidents were, of course, meat and drink to those who had advocated the 'deep shelter' policy and who believed the poor of London were being discriminated against, while the rich either had custom-built luxury shelters or simply sent their children abroad for safety. On 17 September the following leaflet was found to be circulating in a number of shelters:

You have taken things into your own hands. You have taken shelter in the tubes. Quite right too. Over 1000 Londoners have been killed, 4000 wounded because the government refused to build bomb-proof shelters. Certain Cabinet Ministers have sent their children and relatives to America. The rich have safe funk-holes in the country and luxury shelters in hotels and flats in the West End. Sit tight, refuse to leave the Tubes till they build bomb-proof shelters. Your labour, your pennies built the Tubes. The railway millionaires make £40,000,000 profits each year out of you. Form your station committees to act together. Keep the stations tidy, remember they will belong to the workers one day. Join in the fight for a people's government that will build bomb-proof shelters. Join the Communist Party that fights for human lives before profits. Don't let this leaflet become litter. Pass it on to your mates at work, or your neighbours next door. (Issued by the London Branch of the Communist Party of Great Britain.)

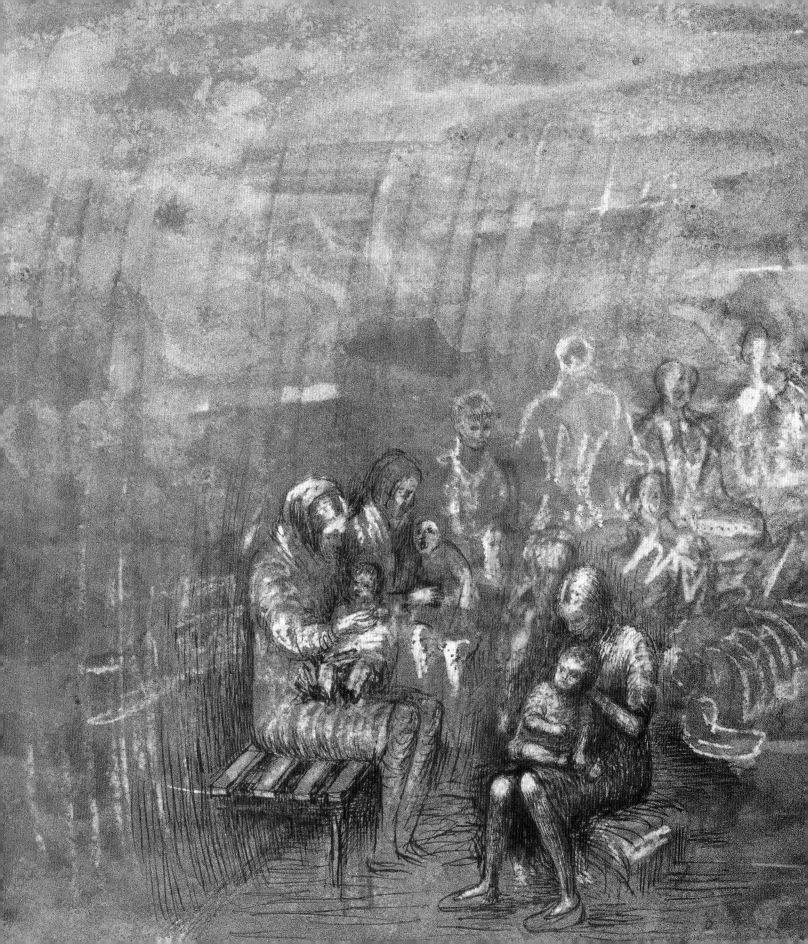

4

Into the Underworld

In the days immediately following the raid of 7 September many people complained that the Germans had been able to carry out their attack without opposition. At this stage in the war British fighter aircraft had no effective equipment for night interception, so the anti-aircraft guns were the only means of hitting back at the bombers. The problems facing Anti-Aircraft Command have already been mentioned, but frantic efforts were now being made to increase the number of guns available for the defence of London. Unfortunately the sound-detection and range-finding equipment servicing these guns was still very inefficient so, unable to find targets, many guns had simply not been fired during the raid. Realising that this failure to retaliate was undermining the morale of Londoners, General Pile decided to act. He gave orders that on the night of 11 September every gun in the London region should fire all its shells into the night sky on a given signal, as soon as the raiders appeared. No fighters would fly over London that night, leaving the sky clear for the guns, and no searchlights would be switched on, to lull the German pilots into a false sense of security.

The effect of this barrage was negligible in terms of damage caused, since no enemy aircraft were shot down over London that night, but it certainly gave the German pilots a shock. Many of them increased their height to try and get above the shell-bursts, making it harder for them to find their targets. Others simply jettisoned their bombs onto the southern and eastern suburbs, and turned for home. For the population of London, though, the noise of the guns crashing out came as a tonic. The sense of relief was palpable, a feeling that they were not just sitting

there waiting for the explosions, but that someone was at last hitting back at the enemy.

One effect of this concentrated fire was that red-hot fragments of steel shell-casing came showering down onto the houses and streets of London. On the mornings after raids children used to scour the streets collecting these pieces of shrapnel as souvenirs. But when the guns were firing the danger of being injured, or even killed, by falling shards of metal was very real. On the night of the barrage, air raid wardens all over London were given orders to keep people off the streets, either indoors or in their shelters, and to prevent anybody from leaving Underground stations. As passengers got off the trains they were told the raid was in progress, and that they should wait below on the platforms until the all-clear sounded.

On the evening of 11 September, Henry Moore and his wife had gone into the centre of London to have dinner with some friends. Unusually, they had gone by public transport because their car was temporarily out of action. They were returning home to Hampstead by Underground when the raid began, travelling on the Northern Line. As the train passed through successive stations they noticed large numbers of people lying on the platforms, and when they got out at their station, Belsize Park, they found they were not allowed to leave. Moore was astonished at the sight which met his eyes:

We stayed there for an hour and I was fascinated by the sight of people camping out deep under the ground. I had never seen so many reclining figures and even the holes out of which the trains were coming seemed to me like the holes in my sculpture. And there were intimate little touches. Children fast asleep, with trains roaring past only a couple of yards away. People who were obviously strangers to one another forming tight little intimate groups. They were cut off from what was happening up above, but they were aware of it. There was tension in the air.[15]

Moore later told the art historian Alan Wilkinson that he had made his first drawing of a shelter scene the day after this first experience at Belsize Park. The drawing was *Women and Children in the Tube* (fig.20) which was later purchased by the WAAC and is now in the collection of the Imperial War Museum. It is a curious drawing, being tentative and impressionistic. The seated figures with children on their laps are drawn in a very naturalistic way, emerging from the gloom of the platform, which is barely hinted at.

But Moore was not the only artist observing this scene. The illustrator and engraver, John Farleigh, also made a powerful drawing at Belsize Park tube station, which he dated 13 September 1940 (fig.21). Although it was not made on precisely the same night as the Moore drawing, the two create an interesting contrast. Where Moore, the modern artist, is here extremely conservative and low key in his depiction of the shelterers, Farleigh, a more traditional illustrator, has produced a marvellously modern drawing, his massive foreground figures foreshortened against the curved wall of the tube tunnel. (Interestingly Farleigh also made another wartime drawing, *I walked through the City*, which precisely parallels a well-known war drawing of a steel girder by Graham Sutherland.)

It is now obvious that Moore did not suddenly

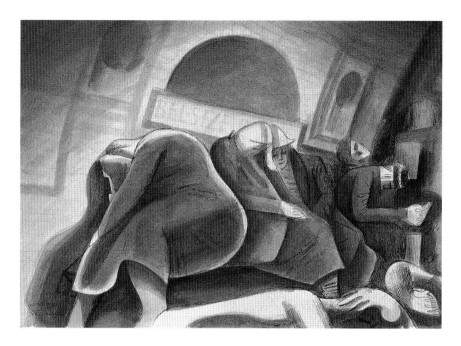

fig.21
John Farleigh
**Shelterers in Belsize
Park Tube Station** 1940
ink, wash and pencil
306 × 453 mm
Imperial War Museum
Ref. IWM ART 16382

plunge into a frenzy of drawing shelter scenes, as has sometimes been assumed. He took his time, continuing to make drawings of ideas for sculptures, but sometimes combining these with tentative sketches of shelter scenes on the same sketchbook page. Although in his later accounts and published statements Moore gave the impression that he filled one sketchbook after another (ie the First Shelter Sketchbook before the Second), it is now clear that he was often working in several different sketchbooks at the same time, referring to a drawing in one book while making a different version of it in another. He remembered buying a number of sketchbooks in Camden Town and was given several others by his sister when she visited him later that autumn. The fact that several of the sketchbooks which were later taken apart were of the same format as the two surviving ones, makes it very difficult to date many of the drawings precisely, or to determine the order in which they were made.

Moore said he 'went into London two or three times a week' to carry out the Shelter Drawings. But a certain amount of mystery still surrounds his actual timetable and working methods. While he was based in Hampstead it would have been quite easy for him to go down into the tube system, travel around visiting different stations for a few hours, and then return to Belsize Park to walk home in the early

hours of the morning. But one weekend in October they went to stay with friends who lived at the small village of Perry Green, Hertfordshire, some twenty-five miles outside London. When they returned on the Monday morning they found Mall Studios had been severely damaged by a bomb. Fortunately no damage had been done to Moore's sculptures, apart from a few scratches, but the place was uninhabitable and they returned at once to Perry Green where their friends were able to look after them. Deciding to look for somewhere to live outside London, they were lucky to find a large and rather dilapidated farmhouse in the same village, part of which was to let. They moved into 'Hoglands', as it was called, but shortly afterwards the tenant of the other half of the house decided to leave and they learned that the whole property was now to be sold. This moment coincided with the sale of the large elmwood figure on which Moore had been working at the start of the war. The money from this sale was just enough to pay the deposit on 'Hoglands', which would remain their home for the rest of their lives.

On 10 October Moore wrote a long letter to Arthur Sale in which he described the problems of settling into this new home. It reveals some of his thoughts about the raids and the plight of the shelterers, though he makes no mention of the fact that he was already drawing them:

> I've had to go up to London two or three times each week for various purposes, since our studio got shaken up, but only once needed to stay the night. I was there yesterday – Chelsea School of Art has had a bomb in the middle of it, not a very heavy one, but leaving only half of the school

useable – and my particular room, the sculpture room, got an incendiary bomb, but that was discovered and put out before it had done more than burn part of the floor.

The unreality of it all, I think, is because of the complete contrast of everyday normal life, side by side with sudden destruction and danger. In the daytime in London, I can't believe any bombs can fall – the streets seem just as full as ever, with people on buses and in the shops, going along just as usual, until you come across a slice of a house reduced to a mess of plaster, laths and broken glass, and on each side above it film sets of interiors with pictures in position on the walls and a bedroom door flapping on its hinges – and of that one's just a spectator, it's like being at the cinema.

The night-time in London is like another world – the noise is terrific and everything seems to be going on immediately over one's own little spot – and the unreality is that of exaggeration like in a nightmare.

But what doesn't seem like a cinematograph reel to me, are the queues, before four o'clock outside some of the tube stations, of poor-looking women and children waiting to be let in to take shelter for the night, and the dirty old bits of blankets and cloths and pillows stretched out on the tube platforms. It's about the most pathetic, sordid and disheartening sight I hope to see.

Sudden destruction, earthquakes and the like, violent death and injury may always come to people however we run the world. But this fearful and miserable nightly tube life seems scandalous. I expect some solution or betterment will be found – if the attack on London continues at its present intensity, which seems pretty certain it will.[16]

The reference to the 'nightly' tube life suggests that he had seen rather more of it since that first time at Belsize Park.

So the moment of Moore's discovery of the shelters as a subject coincided with his move out of London, and the complications of setting up a new home. But how did he make his visits to London, and where did he go during the daytime on those occasions when, according to his accounts, he stayed there for two or three nights in succession? He describes his interest in seeing the damage done to the London streets on emerging from the Underground:

It was strangely exciting to come out onto the street in the early hours of the morning after a big raid, and I used to go down the back streets to see what damage had been done (see pls 8–9). It was on one of these journeys that I saw a whole family – three generations of them – sitting quietly together outside a blasted tenement building, waiting for something to be done for them. And another time I saw an injured girl being brought out of a mass of debris with her hair all fluffed out by dust and plaster.[17]

All these scenes appear among the sketchbook pages.

But he must have had somewhere to go during the daytime, before returning to the tube to make yet more studies of shelterers the following night. Did he

fig.22a
Sleeping Figures 1941
HMF 1755
pencil
126 × 106 mm

fig.22b
Two Sleeping Figures
1941
HMF 1756
pencil
120 × 106 mm

fig.22c
**Sleeping Head and
Hand** 1941
HMF 1757
pencil
120 × 106 mm

fig.22d
Sleeping Head 1941
HMF 1758
pencil
115 × 106 mm
Art Gallery of Ontario,
Toronto

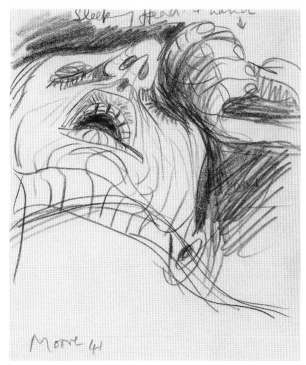

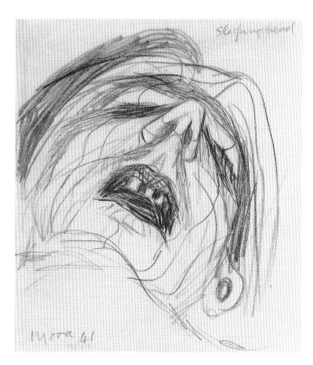

make some use of his own bombed studio space and get some rest during the days? Or was he looked after by friends, where he could get a wash, a bite to eat, possibly some sleep? There are no accounts by anyone seeing Moore at this time, or looking after him, but he had many friends in London and could have stayed in a number of places. Once he got home to 'Hoglands', however, he got down to serious

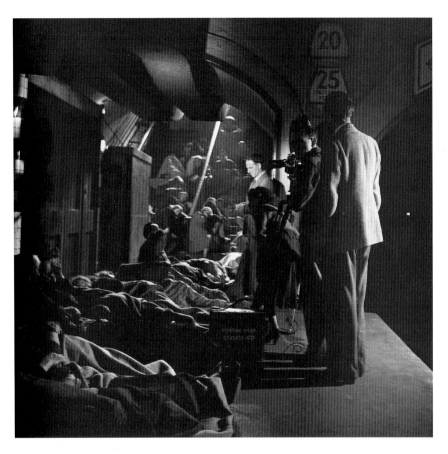

fig.23
Lee Miller
Still photograph from
Out of Chaos
Camera crew filming
Moore at Holborn tube
station
Lee Miller Archives

work on the drawings, initially on the kitchen table before his first studio was ready in a converted garage.

He was using a mixture of media and techniques, often going over a pencil sketch in Indian ink and coloured pencil, laying in a wash of watercolour, then adding touches of gouache for highlights. But the technique for which he became best known through these drawings was the so-called wax resist, which he had discovered shortly before the war, and which appears already in some of the 1939 drawings where he first began using strong colours.

He would use a simple wax crayon, often the white one, to draw in figures or parts of figures, and would then lay a watercolour wash across the same area of the sheet. The watercolour would not take on the waxed sections of the drawing, which would then suddenly stand out in relief against the darker colour of the wash. This is beautifully demonstrated in a shot in the film *Out of Chaos*, in which the film maker Jill Craigie showed how a number of artists, including Moore, were working to record the war. Moore draws

an apparently invisible shape, which magically comes to life as the watercolour goes over it.

Moore was always very anxious to assure people that he never made direct drawings of the people he saw down in the tube shelters: 'Naturally I could not draw in the shelter itself. I drew on my return home … I never made any direct sketches in the Underground. It just wasn't possible. It would have been like making sketches in the hold of a slave ship.'[18] He said the same thing in another letter to Arthur Sale, written as he was finishing work on the Shelter Drawings, in October 1941:

> For the drawings of Underground shelters I did no drawing of course in the Underground itself. I can't see how anybody could have had the cheek to draw people there. I just wandered about and tried not to show that I was looking at anything, and my drawings were made from general impressions and based on what I could remember when I got home.[19]

But these assertions run counter to other statements he made later, to the effect that he did carry a very small sketchbook, or tear-off pad, 'for jotting down ideas'. There are also indications that he may have carried one of the larger sketchbooks with him on occasions. He mentions that he 'would wander casually past a group of people half-a-dozen times or so, pretending to be unaware of them', and that he would then go round a corner or up a staircase 'so that I could write down a note on the back of an envelope without being seen.'[20] Is this a case of protesting too much? One can well understand that he felt sensitive about intruding on people's privacy

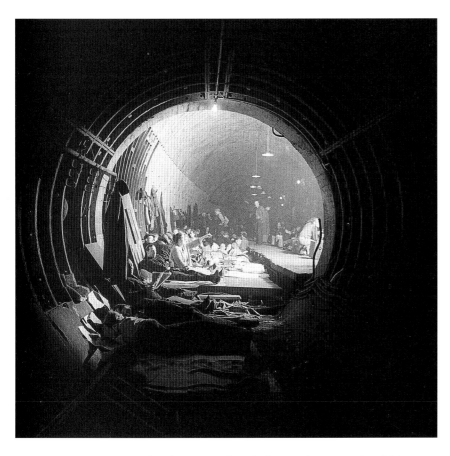

fig.24
Bill Brandt
Liverpool Street
Extension tunnel
Imperial War Museum
Ref. D1673

in what were often intimate situations, in which shelterers felt self-conscious and vulnerable. It would not have been appropriate to have been seen sketching people in these circumstances, where to have been accused of voyeurism could have led to unpleasantness. He might also have been accused of being a fifth columnist or a spy.

Nevertheless it is hard to resist the conclusion that Moore was making initial pencil sketches while down in the Underground, even though he was being very careful. Many of the highly worked mixed-media drawings which fill both the First and Second Shelter Sketchbooks can be seen to have pencil under-drawing, and the suspicion must be that this was either carried out directly in the tube (if not in front of the subject) or was copied from another, possibly smaller, drawing which certainly was. Moore said that he threw away all his 'back-of-an-envelope' notes, but luckily a few small-size pencil drawings have survived which may have come from the small sketchbook or tear-off pad mentioned. These are the drawings of *Sleeping Figures* and *Sleeping Head*

(fig.22) which have clearly been executed quite quickly, and which all exist in fuller, more worked-up versions, both within the surviving sketchbooks and among the larger finished drawings.

But there is another reason why Moore may have felt a need to keep emphasising that he never made drawings in the shelters. A photograph was taken, and subsequently very widely publicised, which shows him apparently doing just that, posed with sketch-pad in hand, in front of a large mass of sleeping figures. This photograph, which has been used in many books and catalogues, creates precisely the impression that Moore wanted to avoid. It was taken by Lee Miller, who was engaged to take still shots of the scenes of Henry Moore which Jill Craigie was filming in Holborn Tube station in September 1943, more than two years after he had finished the Shelter Drawings. Altogether Lee Miller shot two rolls of interesting pictures, some of them showing Moore together with Craigie, cameramen and lighting technicians (fig.23). But it was that one, rather misleading image, that was to be so much publicised and one can understand how this must have irked Moore.

In January 1941 Moore signed an agreement with the WAAC to provide drawings of 'a series of Civil Defence Subjects … the number and size to be a matter for mutual arrangement … subjects to be chosen at your discretion.'[21] From this moment on his semi-official status meant he could obtain a sketching permit, which would allow him past officious wardens who might want to bar him entry to certain shelters, and he also became entitled to a petrol ration. But for more than three months, from September to the end of December 1940 when the

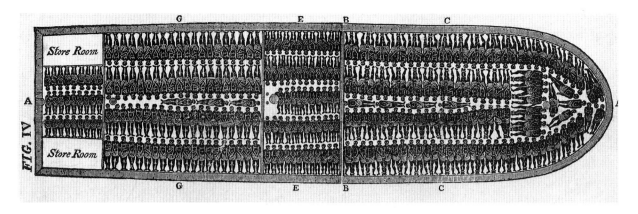

fig.25
Plan of a Slave Ship
Wilberforce House: Hull
City Museums and Art
Galleries

fig.26
**Tube Shelter
Perspective** 1941
HMF 1802
pencil, wax crayon,
coloured crayon,
watercolour wash, pen
and ink
432 × 422 mm

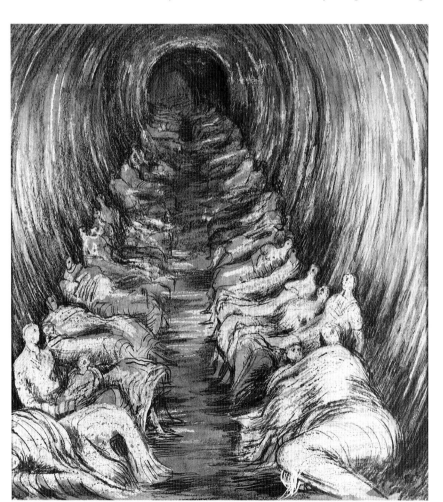

raids were at their height, he had been quietly engaged on the Shelter Drawings without any permit at all. His limited petrol allowance would have been quickly used up, so presumably he went in and out of London by his local train from Much Hadham to Liverpool Street. So it was not surprising that among the many tube shelters he liked to visit was the new extension tunnel built beneath Liverpool Street Station, for a branch of the Central Line out to Bethnal Green, in which the rails had not yet been laid. This tunnel, and one or two other similar ones in other parts of London, provided shelter for huge numbers of people, albeit in rough conditions (fig.24).

On more than one occasion Moore compared the shelters to the hold of a slave ship – a slightly odd comparison, perhaps, if one had not seen the long rows of figures lining the sides of the Liverpool Street extension. But is it perhaps possible that Moore, seeing the tunnel shelterers, subconsciously remembered an image of a real slave ship that he had seen somewhere? A very powerful image does exist, at the Wilberforce House Museum in Hull, Yorkshire, showing rows and rows of captive slaves imprisoned below the decks of the Liverpool slaver, *Brookes*. We do not know whether Moore ever visited this museum, but a print showing the arrangement of the slaves (fig.25) was widely reproduced, and the comparison with his *Tube Perspective* drawings is striking (fig.26).

In moving around the Underground system looking for interesting shelters Moore would have stayed mainly on the deep tube lines, the Bakerloo, Central, Piccadilly and Northern. These often average a depth of around sixty feet below ground level in the centre of London, the deepest of all being the Central Line at Holborn which reaches a depth of one hundred feet. None of the bombs being used by the Germans could penetrate to these levels, though a number of tube stations did get hit, including Bank, Camden Town and Trafalgar Square (now part of

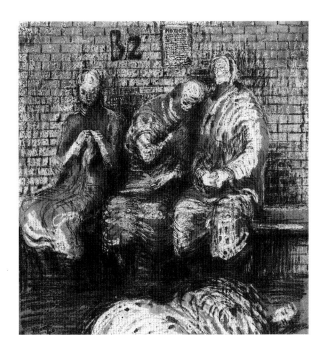

fig.27
Shelter Drawing 1940
HMF 1731
pencil, was crayon,
coloured crayon,
watercolour, pen and ink
289 × 273 mm
The Moore Danowski
Trust

fig.28
Shelterers in the tube
Imperial War Museum
Ref. IWM D1539

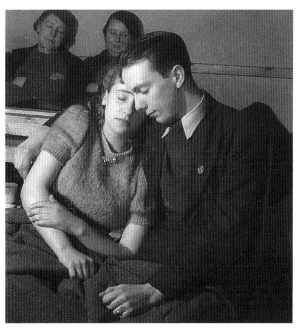

Charing Cross) in the centre, and Balham on the southern branch of the Northern line, where a flood of mud swamped a platform causing many deaths. Moore's progress through the tubes can be followed in the drawings, but it should be remembered that he also visited some surface shelters, notably the huge warehouse basement known as Tilbury.

Tilbury was located in the East End of London, between the Commercial Road and Cable Street in Stepney, close to the junction of the Whitechapel Road and Aldgate. The building had been constructed in 1886 as the warehouse for the goods depot of the London, Tilbury and Southend Railway, with a direct rail link to Tilbury Dock – hence the name. It was visited by a number of artists besides Henry Moore, including Edward Ardizzone and Feliks Topolski, who both drew lively scenes there, and is described in detail in the book *Bomber's Moon* by Negley Farson, an American journalist resident in London. This book also contains a number of excellent, tender sketches of scenes inside Tilbury by Tom Purvis, a commercial illustrator and designer, which make an interesting parallel to Moore's drawings.

Tilbury is also described in detail in Tom Harrison's book, *Living through the Blitz*, which draws on reports by observers from Mass Observation who visited this shelter. One of the first of these reports describes East Enders kicking down

the padlocked door of one of the entrances to the basement, to gain access while a raid was in progress.

Tilbury was enormous, having long concrete platforms divided up by arched loading bays. One of Tom Purvis' drawings shows a row of lorries parked inside it. At the time the East Enders took it over it also contained horses (and their manure), a narrow railway track, stacks of crates of margarine, and huge rolls of paper for newsprint. As a shelter it was totally unofficial, but within a short time an informal shelter committee had been formed, improvised shelter rules were drawn up, and each arch or bay had its own local shelter marshal, usually a woman, to reserve spaces for her regulars, keep out intruders and enforce good behaviour – as far as possible (figs 27–28). As many as 8000 people regularly poured into Tilbury during the worst of the raids in the autumn of 1940 – even 10,000 at times – and conditions were indescribable, with only two running water taps in the entire space. The population of the shelter included many Jews of Polish or Russian origin, but there were also Chinese from Limehouse and people from many other races and creeds, that extraordinary mixture of immigrants that made up the East End. A note on one of Moore's drawings refers to 'Lascars – bundles of old clothes that are people'; these were Indian merchant seamen,

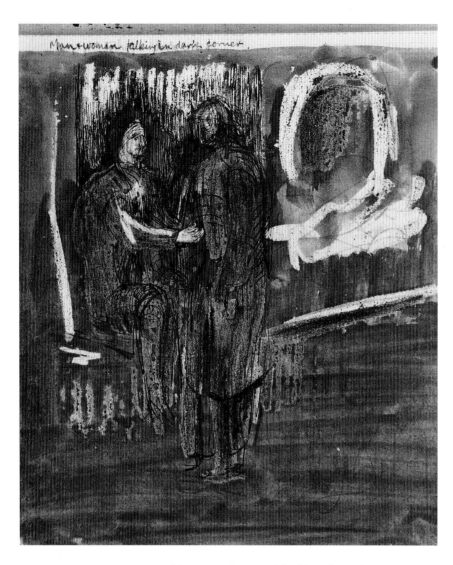

fig.29
**Man and Woman
Talking in a Dark Corner**
1940–41
HMF 1641
pencil, wax crayon,
coloured crayon,
watercolour wash, pen
and ink
Second Shelter
Sketchbook p.16
The Henry Moore
Foundation

working as stokers and deckhands on the cargo ships that filled the Port of London.

Although smoking was theoretically banned it was informally permitted in some parts of the basement to combat the stench. There were frequent disagreements, and sometimes fights, between the shelterers, especially if the occupants of one bay were trying to get some rest close to another where an informal concert was in progress. Persistent drunks caused regular disturbances, women had almost no privacy to breast-feed children, sanitary facilities were limited to buckets, and sexual intercourse took place openly in the dark areas beyond the railway track.

For Henry Moore, who had had quite a sheltered upbringing, and who was very reserved in personal matters, these scenes clearly came as something of a shock. Although his experiences as a ranker in the First World War had taught him to get on with people of all kinds in difficult circumstances, this was probably the first time in his life that he had found himself in such surroundings. While he would have seen some districts of north-east London from the train, when travelling to visit his sister and her family in Essex, he would have known very little about the East End proper. He had originally lived as a student in Chelsea, studied at the Royal College in Kensington, taught at Chelsea School of Art, lived in a studio in Hampstead, and regularly visited the British Museum – but until the Blitz he had probably never been further east in London than Liverpool Street Station. What he had found in the Underground had already worried him, but the scenes he found in Tilbury clearly confirmed the impression he expressed in his letters: that the poorer classes of Londoners were being neglected by the authorities.

The written notes on many of the Shelter Drawings give useful insights into his concerns. It is true that many of these indicate his continuing interest in sculptural shapes, and are reminders of particular positions that he wanted to capture: 'try position oneself … do abstract drawing of scene … sculptural form idea … people in bunks like Etruscan reclining figures….' But rather more of his notes are comments on the people, and the state they were in, the grim nature of their surroundings and their evident stoicism in the face of these awful conditions:

sick woman in Bath chair … women and children with bundles … bearded Jews blanketed sleeping

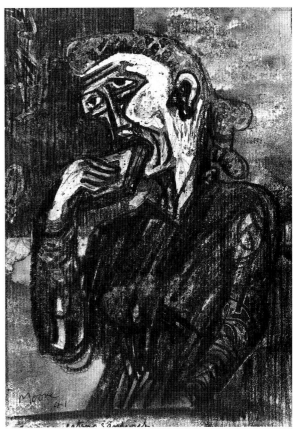

fig.31
Shelter Drawing:
Woman Eating
Sandwich 1940–41
HMF 1838
pencil, wax crayon,
coloured crayon,
watercolour wash
177 × 125 mm
The Moore Danowski
Trust

fig.30
Two Figures Taking a
Snack in a Shelter
1940–41
HMF 1720
pencil, wax crayon,
coloured crayon,
watercolour wash, pen
and ink
Second Shelter
Sketchbook p.95
The Henry Moore
Foundation

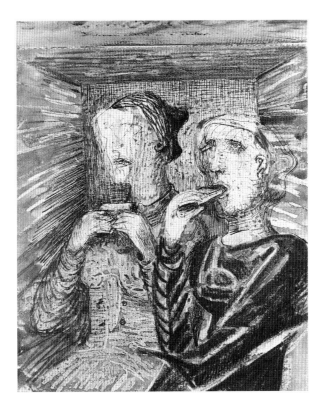

in deck-chairs … all kinds and colours of blankets, sheets and old coats … men with shawls to keep off draughts, women wearing handkerchiefs on heads … woman and girl eating in a shelter … short-sighted man reading in Underground … children keeping shop in a shelter … sleeping expressions, pity and abandon.

On several of the Tilbury drawings there are notes which suggest an awareness of the risk of intruding: 'dark, wet settings … far end of Tilbury shelter, platforms with people in dark corners … man and woman talking in a dark corner.' (fig.29)

There is a huge contrast between drawings such as *Two Half-Length Seated Figures* (pl.76), that seem to hark back to Renaissance figures, and the much harsher images of *Two Figures Taking a Snack in a Shelter* and *Woman Eating a Sandwich* (figs 30 & 31). At times it seems as though Moore is trying to draw heads in the style of Picasso, but not very successfully. He had visited Picasso in Paris not long before the war, when he had seen *Guernica* in progress. Later in his life he owned a copy of Picasso's *Guernica* lithograph, which he kept permanently on the wall of his kitchen. He would also have been familiar with Picasso's *Weeping Woman*, to which fig.31 bears a very superficial resemblance. Several of these heads may seem to jar slightly, in comparison to the sensitive and moving depictions of other shelter figures, but at this distance it is easy to forget how Picasso's influence dominated other artists in the middle of the twentieth century.

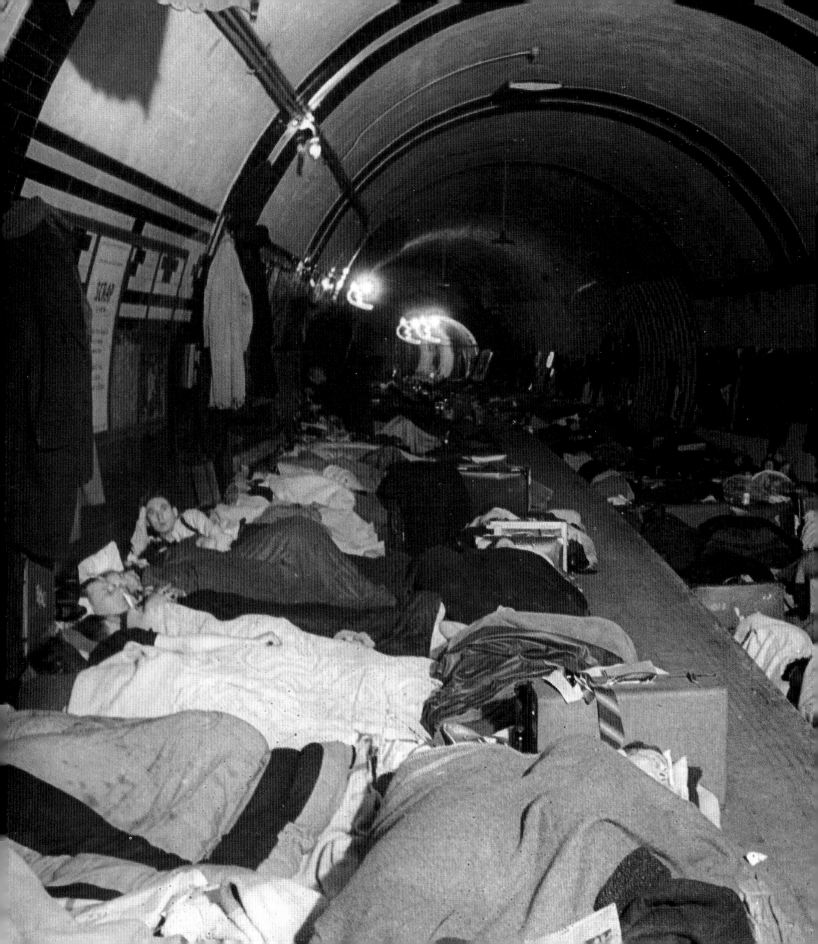

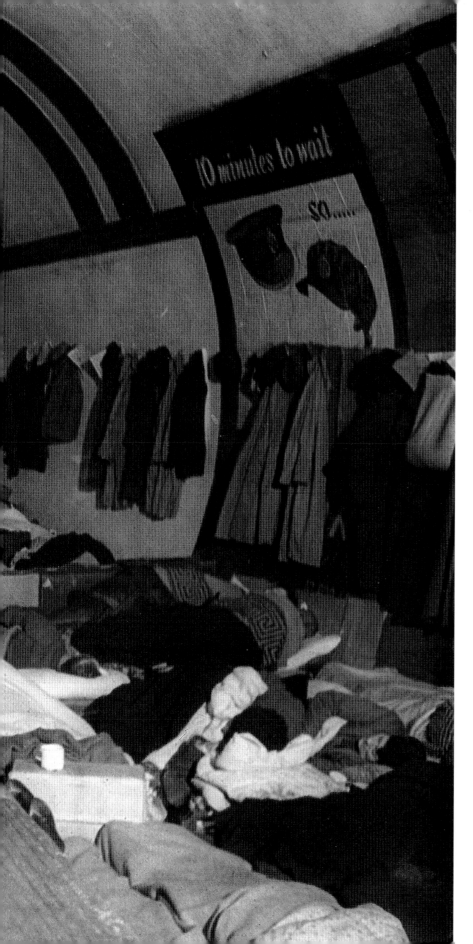

Conclusion

As he started to wind down from making the Shelter Drawings, Moore was approached on several occasions with requests for him to record other subjects. Invariably he would express polite interest but then ignore the request completely. He did not like to be told what he should draw. Eventually he was persuaded to visit an ordnance depot to make drawings of 'objects dropped from the air' – presumably it was felt that, as a sculptor, he would be interested in these shapes. The visit lasted one day only: after filling two pages of a sketchbook with drawings of shell-casings, Moore abandoned the project without another word (fig.33).

A clue to his feelings comes in his comment about the coal-mining drawings, which were his one real commission from the WAAC, when he genuinely was working as an official War Artist. He had accepted this project because he was interested in the chance of returning to the Yorkshire pit where his father had worked and experiencing something of the conditions that miners endure on a daily basis. He found this experience a chastening one, but the resulting drawings are extremely beautiful, though consistently under-appreciated. Moore was dismissive, saying that while he was glad to have had the experience, the drawings were no more than 'a Commission, coldly approached', whereas the Shelter Drawings had been undertaken because he had been deeply moved by the subject.

The influence of the Shelter Drawings on Moore's later work can barely be touched on in this study. The view that the use of drapery in his post-war figures came from the Shelter Drawings has, perhaps, been overemphasised. Drapery, after all, is a feature of much of the classical Greek and Roman sculpture he

(previous page)
fig.32
Shelterers in the tube
Imperial War Museum
Ref. D1677

fig.33
Three Bomb Cases from an Army Museum 1943
HMF 1855
pencil, wax crayon on cream medium-weight wove
210 × 165 mm
The Henry Moore Foundation

fig.34
Sleepers in the tube
Imperial War Museum
Ref. D1545

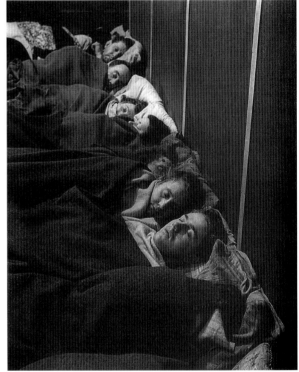

had admired for many years at the British Museum. Whether his later works really became more 'human', as has sometimes been suggested, is also debatable, since the *Reclining Figure* and the *Mother and Child* were already favourite Moore themes before the war, while some of his finest abstract works were made in the 1960s and 1970s.

Not everyone liked the Shelter Drawings. Bernard Meadows felt 'they didn't stretch him sufficiently',[22] and that in continuing with them Moore was allowing himself to be too much influenced by Kenneth Clark. Many people felt they exuded an uncomfortable atmosphere of death and decay, the lines of figures in the tunnels being seen not as larvae awaiting rebirth, but as entombed inhabitants of a buried city, awaiting discovery by an archaeologist.[23] The painter Keith Vaughan, anonymous reviewer of a War Artists' exhibition in Penguin New Writing, commented on the effects produced by Moore's use of his mixed-media technique, saying that 'a fungoid phosphorescent texture covers skin, drapery, and the walls of the tunnels'. Others have read them in a similar way, one comparison being to the lines of

casts of human figures lying in the ruins of Pompeii. Some of Moore's 'sleepers' look uncannily like these figures which are, in effect, sculptures (figs 35 & 36). During the first half of the twentieth century the excavations at Pompeii held a similar fascination in the public mind as the wreck of the Titanic has done since its discovery in 1985. One reason for this was the enormous number of popular films made about the earlier disaster. In addition to three documentaries about Pompeii and three others of the 1906 eruption, the Bulwer-Lytton novel *The Last Days of Pompeii*, was filmed no fewer than twelve

fig.36
Victims of Mount
Vesuvius
Photo: Julian Andrews

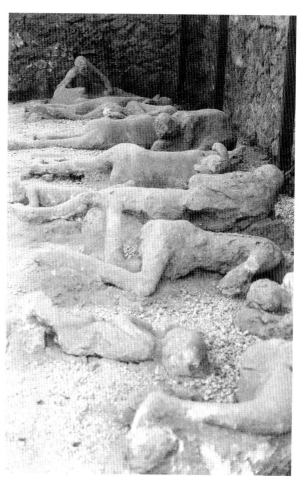

fig.35
**Study for 'Row of
Sleepers'** 1940–41
HMF 1657
pencil, wax crayon,
coloured crayon,
watercolour wash
Second Shelter
Sketchbook p.32
The Henry Moore
Foundation

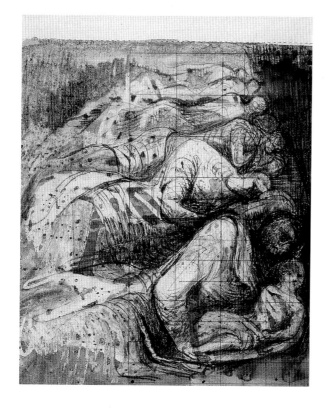

times between 1900 and 1939. This was precisely
when fear of air raids was becoming widespread, and
it would not have been surprising if Moore's images
triggered subconscious impressions, in some people,
of being suffocated under ash. Even the appearance
of blitzed streets prompted such images, the writer
Graham Greene referring to 'the strange torn
landscape where London shops were reduced to a
stone ground-plan like those of Pompeii'.[24]

In general, though, the drawings were
appreciated by many of those who had lived through
the Blitz, as powerful depictions of the experience of

survival. Looking at these images gave a sense of
having shared that experience with hundreds of
thousands of others, which in itself was a form of
catharsis. Although continual use of the drawings in
books, catalogues and magazines about the war has
tended to equate them with wartime propaganda,
their origins remain unchanged. They were the
spontaneous personal expression of an artist's
feelings about the impact of war on ordinary people:
'This was something I had to do'.

In one respect the Shelter Drawings have not
dated. Sixty years on from the Battle of London, at
the start of a new millennium, innocent civilians are
still being bombed. The issues that stirred Henry
Moore's feelings then, remain a matter for our
concern today.

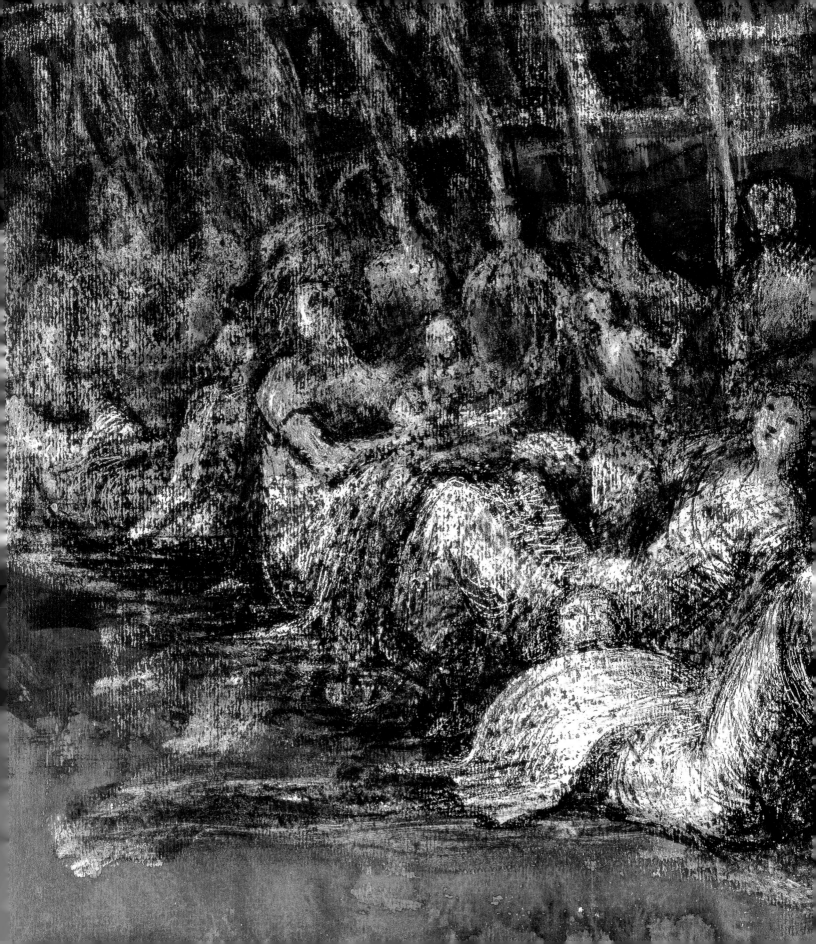

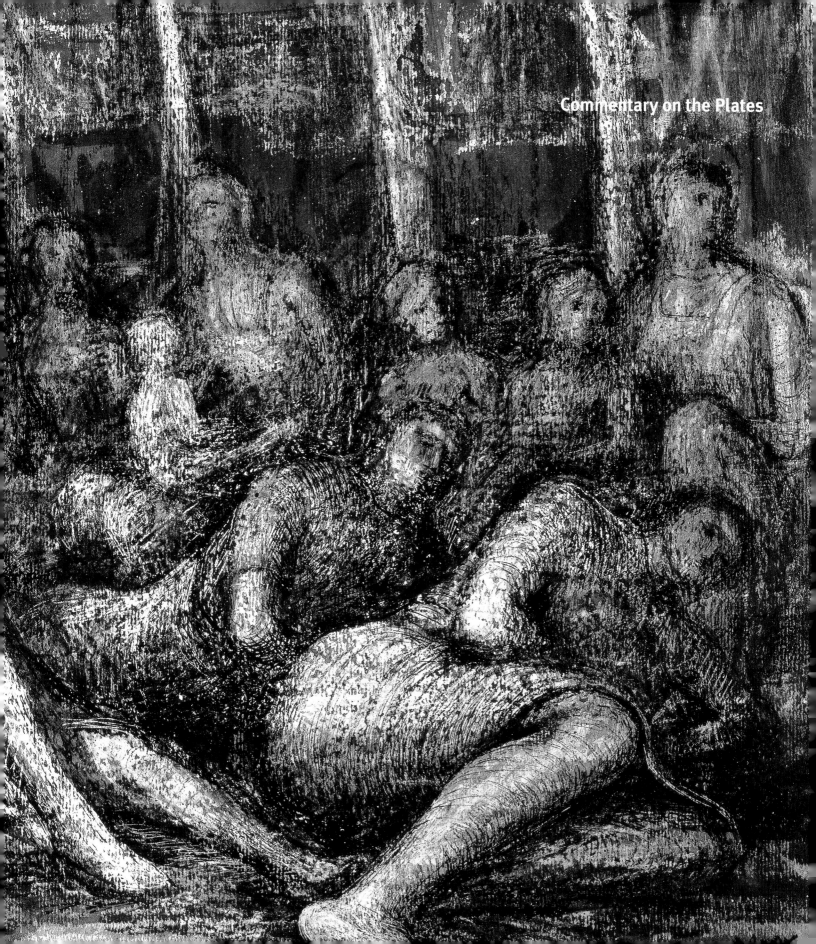

Experiments in War Drawings

In the opening pages of both sketchbooks realistic and imaginary subjects are mingled together on the same sheets, along with abstract sculptural forms. It is as though Moore is not sure what his real subject is. The glare of the blazing docks rises from behind gutted, burned out buildings. The dark silhouette of the London skyline looms over a desolate landscape filled with strange shrouded shapes, a tiny group of shelterers beside a ruined brick wall. The softness and vulnerability of sheltering figures stands out against jagged walls and twisted girders of bombed buildings – a contrast of opposites. Barbed wire cuts across the rounded form of a bone sculpture, while another form opens out like a flower to receive a bomb, from above.

Plate 10 is an almost classical study of figures that foreshadows Moore's post-war family groups. Comfortably seated on a low bench, they bear no relation to the bombed buildings behind them, which serve merely as a theatrical backdrop.

One of the early sketchbook pages includes a tiny drawing of people crowded together on the platform of a Tube station (pl.37). It must be one of the first of these scenes, carried out from memory at about the same time as he drew *Women and Children in the Tube* (fig.20), discussed earlier, the realisation of his experience of the night spent in Belsize Park Station.

1
Eighteen Ideas for War Drawings 1940
HMF 1553
pencil, wax crayon, coloured crayon, watercolour wash, pen and ink
274 × 376 mm
The Henry Moore Foundation

(previous page)
fig.37
Shelterers in the Tube
(detail), see p.63

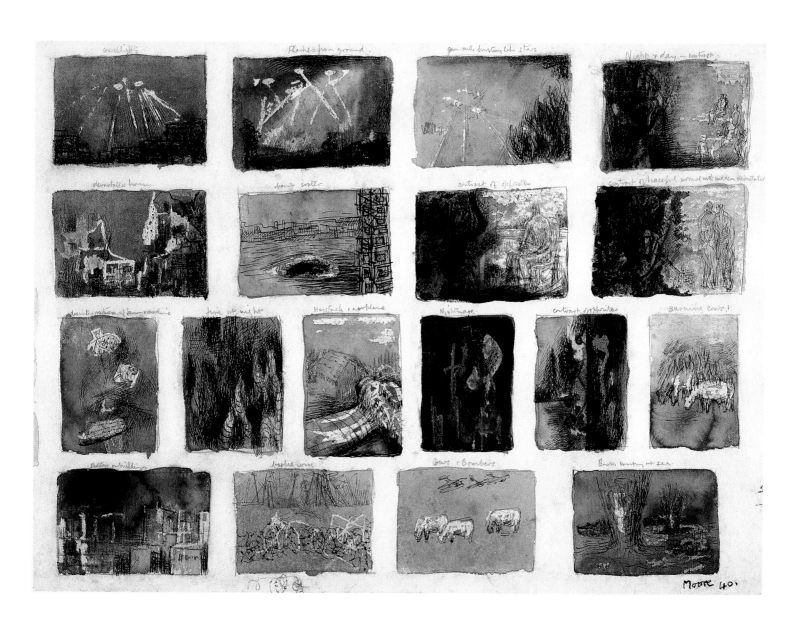

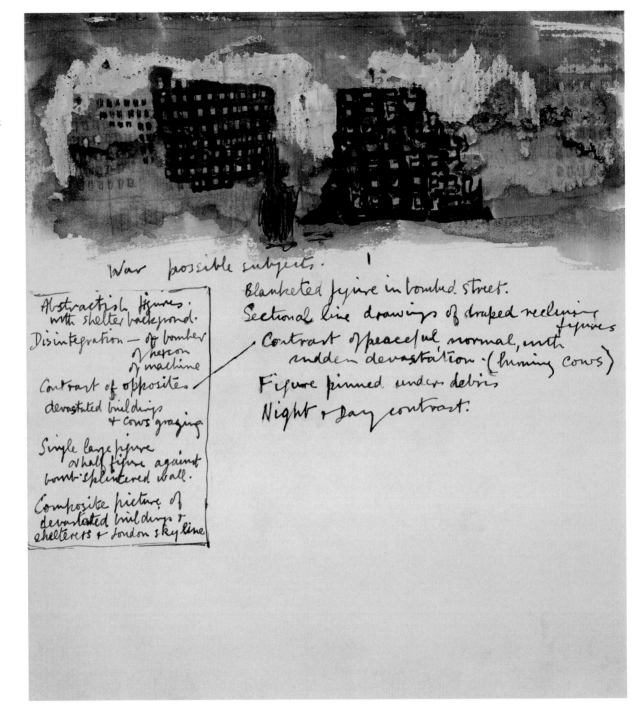

2
War: Possible Subjects
1940–41
HMF 1603
pencil, wax crayon,
watercolour wash, pen
and ink
First Shelter Sketchbook
p.45
The British Museum

3
London Skyline 1940–41
HMF 1574
pencil, wax crayon,
coloured crayon,
watercolour wash, pen
and ink
First Shelter Sketchbook
p.16
The British Museum

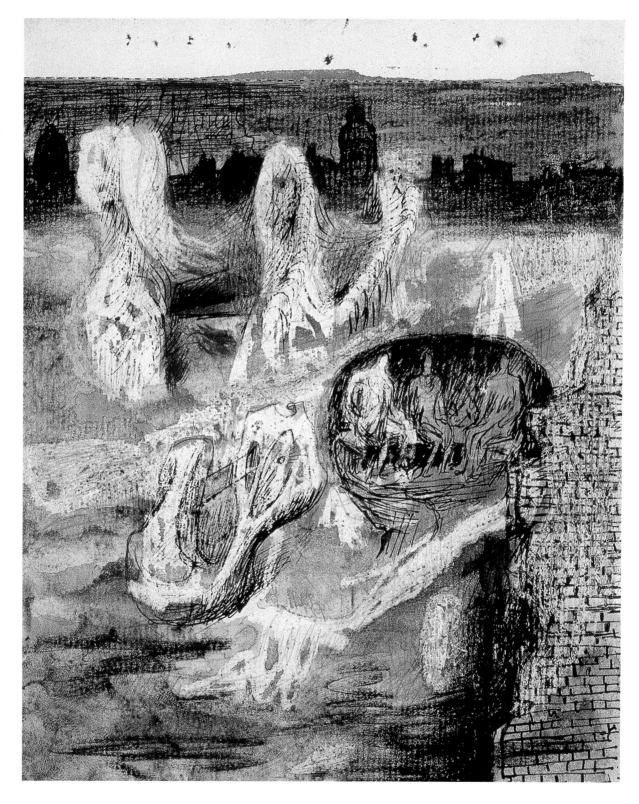

4
**Blitzed Buildings and
Sleeping Woman
Holding Child** 1940–41
HMF 1623
pencil, wax crayon,
watercolour wash, pen
and ink
First Shelter Sketchbook
p.65
The British Museum

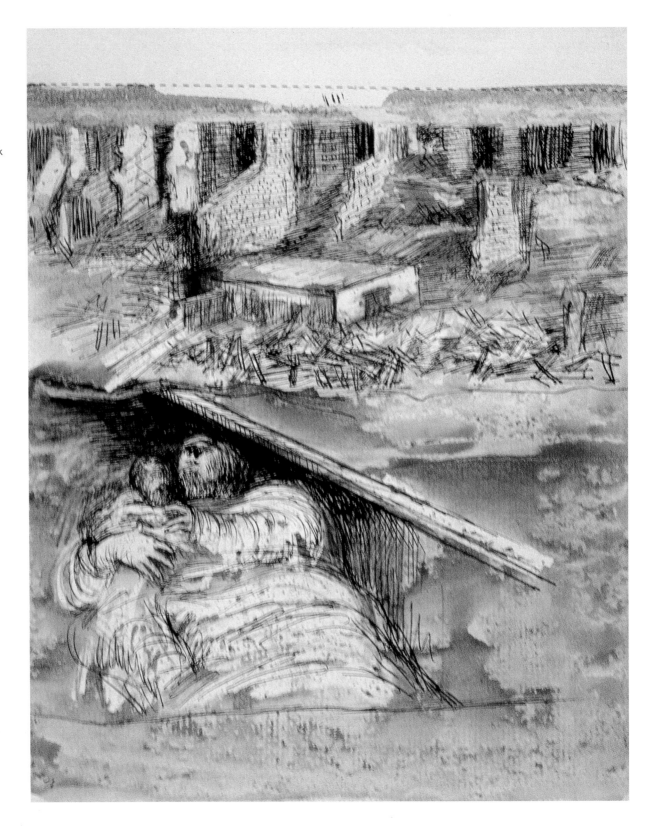

5
**Air Raid Shelter
Drawing: Gash in Road**
*c.*1940
HMF 1557
pencil, wax crayon,
chalk, watercolour, pen
and ink
381 × 279 mm
Private collection UK

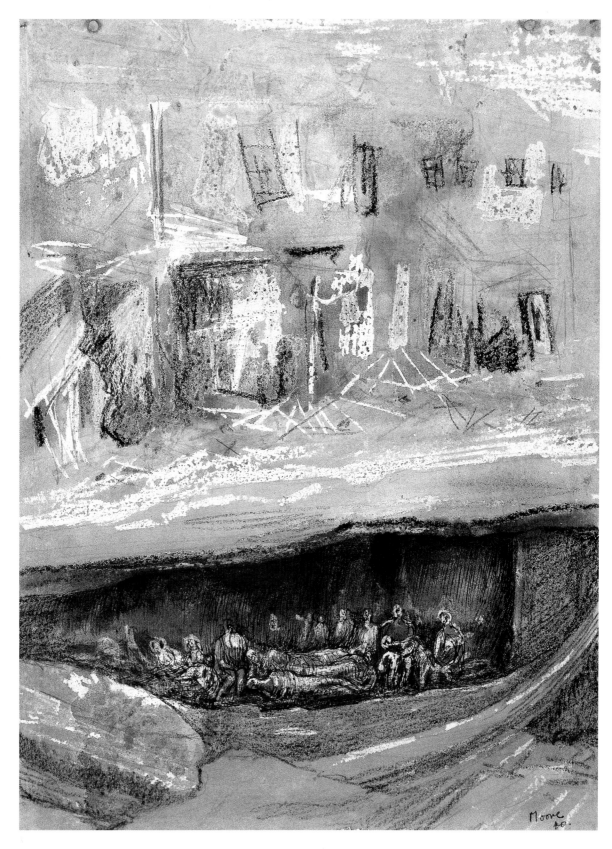

6
**Bone Studies and
Reclining Figure**
1940–41
HMF 1570
pencil, wax crayon,
coloured crayon,
watercolour wash, pen
and ink
First Shelter Sketchbook
p.12
The British Museum

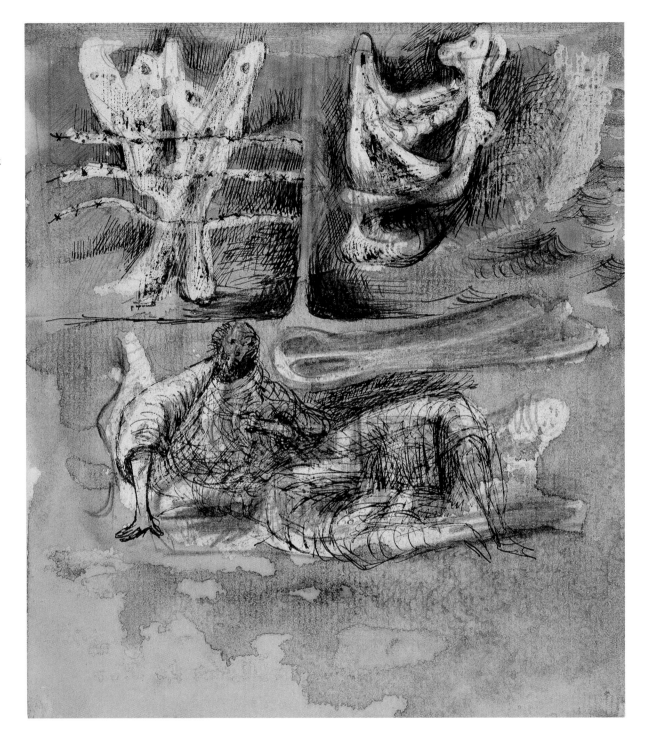

7
**Devastated Buildings
and Underground
Platform Scene**
HMF 1562
1940–41
pencil, wax crayon,
coloured crayon,
watercolour wash, pen
and ink
First Shelter Sketchbook
p.4
The British Museum

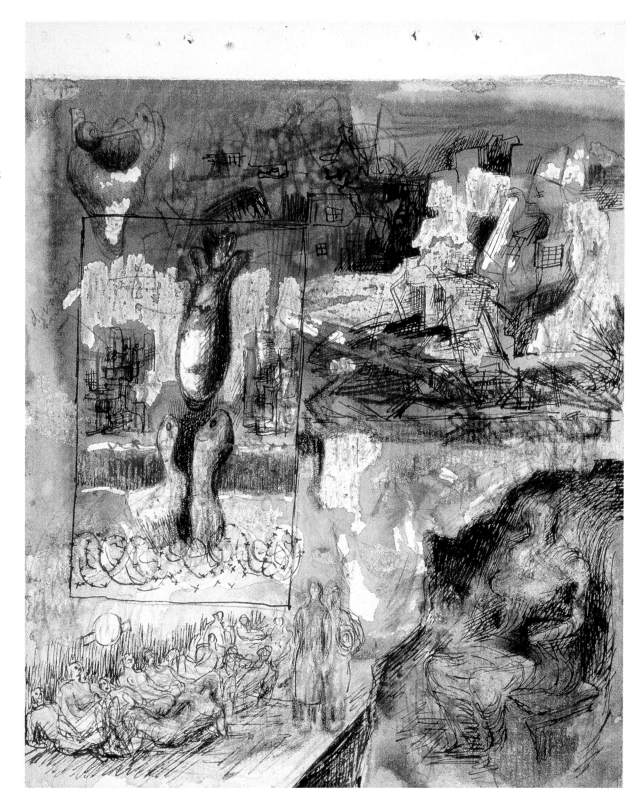

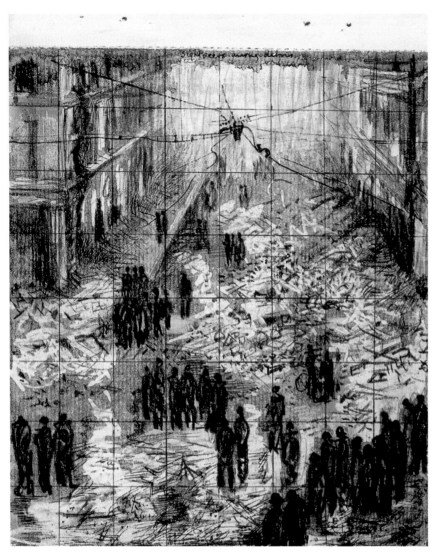

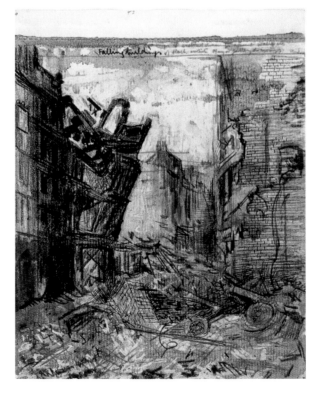

8
Study for 'Morning after the Blitz' 1940–41
HMF 1685
pencil, wax crayon, coloured crayon, watercolour wash, pen and ink
Second Shelter Sketchbook p.60
The Henry Moore Foundation

9
Falling Buildings: The City 30 December 1940
1940–41
HMF 1686
pencil, wax crayon, coloured crayon, watercolour wash, pen and ink
Second Shelter Sketchbook p.61
The Henry Moore Foundation

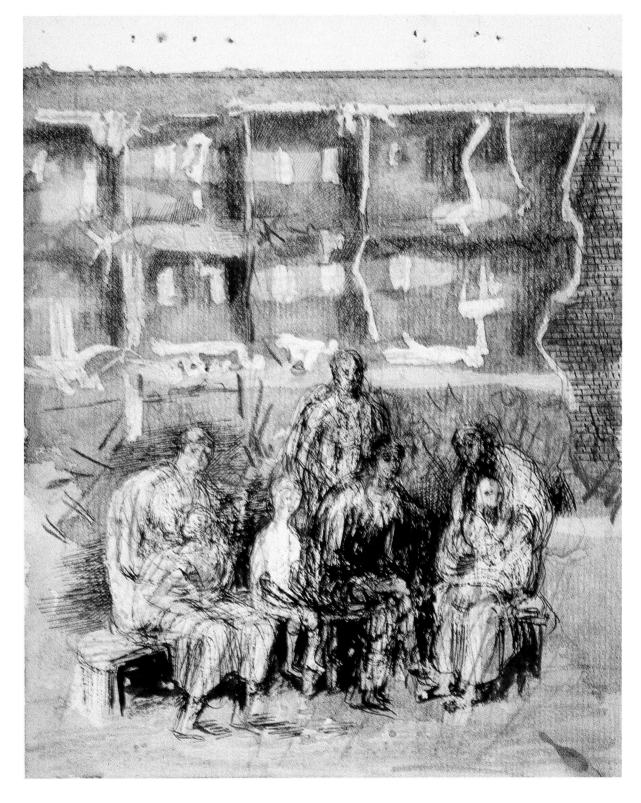

First Tube Shelter Sketches and Drawings

'I was fascinated. I went back again and again.' Such was Moore's own description of his discovery of the tube shelter scenes. It is clear that he visited many different stations, travelling from one to another late at night on the lines where trains were still running.

Many of the sketches are tiny, yet the effect is of huge spaces and vaults, vast numbers of people. These drawings were worked up from faint pencil sketches, just visible beneath the ink and wash, which Moore must have scribbled surreptitiously, propped against walls, on staircases and in any quiet corner where he could escape being observed.

The sketches are shown with a number of the larger finished drawings derived from them. Seeing them together one can follow the development of Moore's ideas and understand his fascination for the dominant curve of the tunnel walls, with the mass of vulnerable tiny figures beneath. The structural grid of the girders in the unfinished tunnel of the Liverpool Street extension interested him particularly. In formal terms the curved vertical girders cut across the straight lines of the horizontal ones, setting up a strong pattern of parallelograms that contrasts with the amorphous huddle of humanity.

In *Brown Tube Shelter* and *Grey Tube Shelter* (pls 15 & 16) the groups of figures are more sculptural, and are seen from directly in front. But a tube platform is only twelve feet deep, from the curved wall at the back to the platform edge. While shelterers were using the stations the last three or four feet were left clear for passengers to get in and out of trains. So Moore's viewpoint is an imaginary one, since he would have had to have been somewhere above the rails to get this full-on angle. Here, his aesthetic, sculptural interest in the groupings of the figures has come to the fore, while there remains a strong sense of pity and social concern. This is expressed through the complex texture of the mixed media used in the drawings, with their subdued colours.

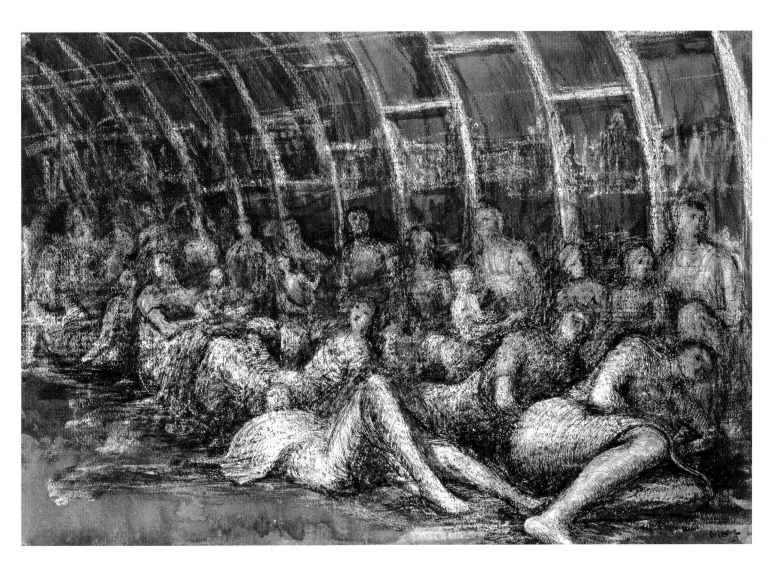

(opposite)

11

**Women and Children
with Bundles** 1940–41
HMF 1631
pencil, wax crayon,
watercolour wash, pen
and ink, gouache
Second Shelter
Sketchbook p.6
The Henry Moore
Foundation

12

Shelterers in the Tube
1941
HMF 1797
pencil, wax crayon,
chalk, watercolour wash
381 × 559mm
Tate, London

13
**Underground
Sheltering**
1940–41
HMF 1579
pencil, wax crayon,
watercolour wash, pen
and ink
First Shelter Sketchbook
p.21
The British Museum

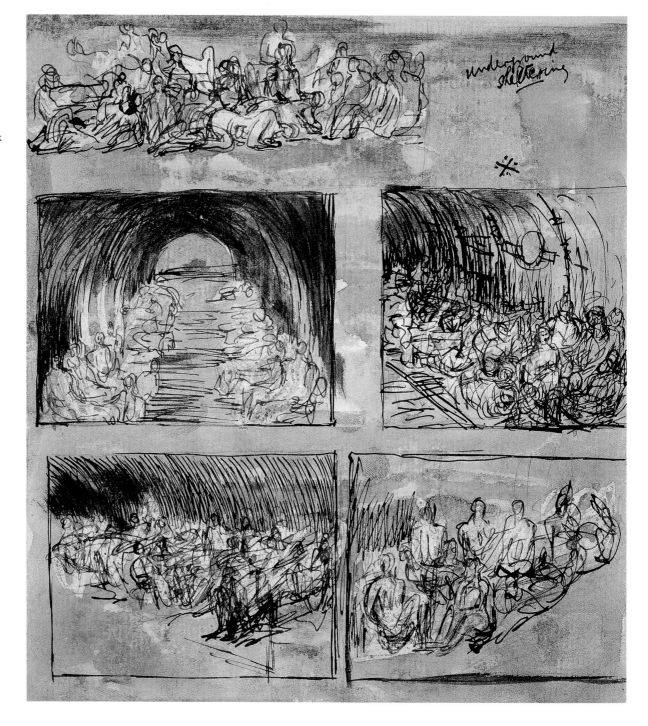

14
Tube Shelter Scenes
1940–41
HMF 1629
pencil, wax crayon,
watercolour wash, pen
and ink, gouache
Second Shelter
Sketchbook p.4
The Henry Moore
Foundation

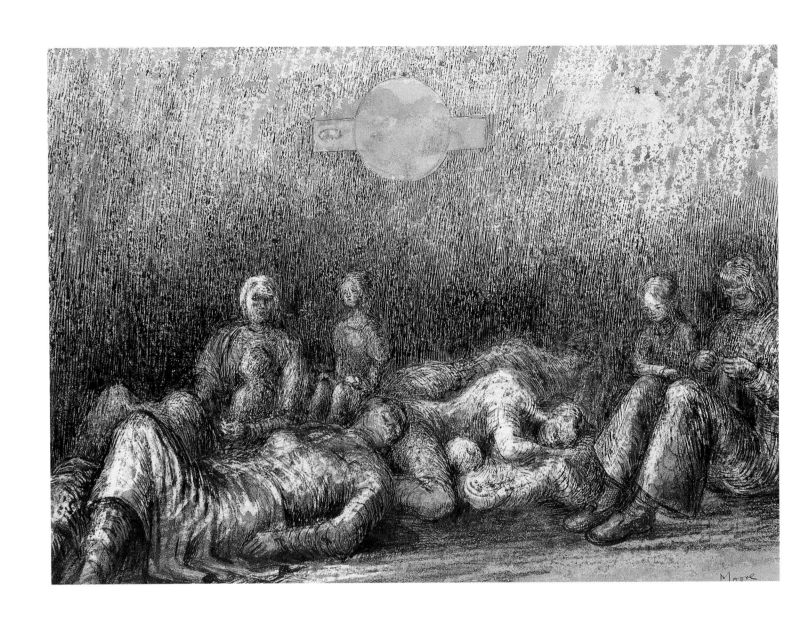

15
Brown Tube Shelter
1940
HMF 1722
pencil, wax crayon,
watercolour wash, pen
and ink
277 × 378 mm
The British Council

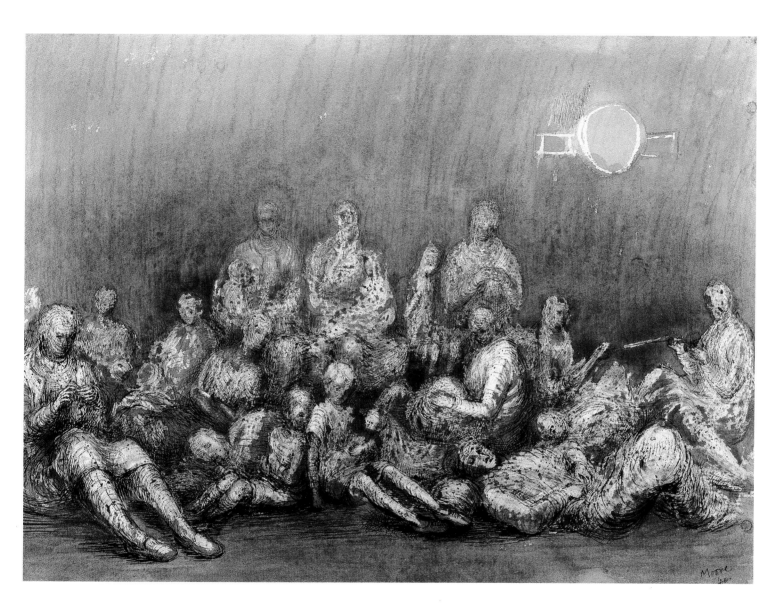

16
Grey Tube Shelter 1940
HMF 1724
pencil, wax crayon,
coloured crayon,
watercolour wash, pen
and ink
279 × 381 mm
Tate, London

67 First Tube Shelter Sketches and Drawings

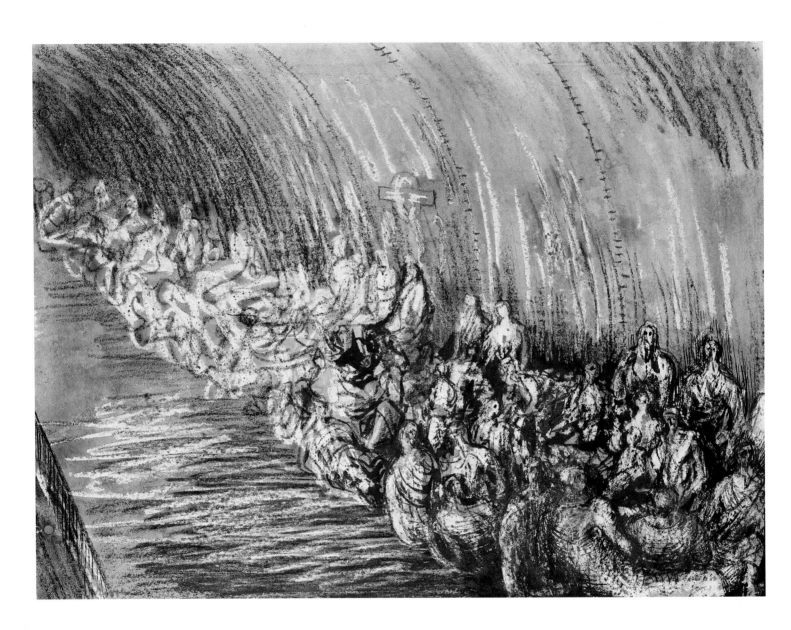

17
Tube Shelter 1940
HMF 1725
pencil, wax crayon,
coloured crayon,
watercolour wash, pen
and ink
279 × 381 mm
Private collection

68 London's War

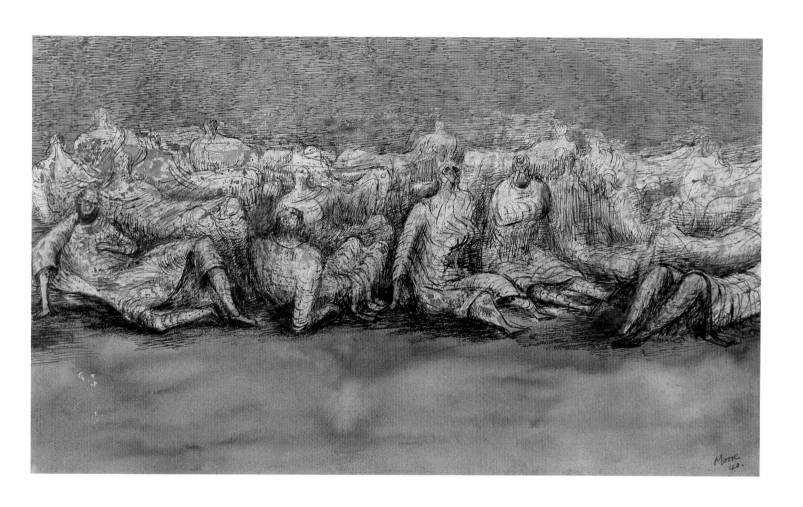

18
Groups of Shelterers
1940
HMF 1736
pencil, wax crayon,
watercolour wash, pen
and ink
254 × 432 mm
Robert and Lisa
Sainsbury Collection
University of East
Anglia, Norwich

Single Figures and Pairs of Figures in Underground Shelters

Several of the pages from the First Shelter Sketchbook show figures that may well be members of Moore's own family, used as models. It is known that he made a number of studies of his sister Mary, and her young daughter, at this time. Pages 22 and 24 of the sketchbook show two such examples. Earlier on we saw the page in between, showing a seated figure knitting, juxtaposed with a photograph of a shelterer on a tube platform (figs 18–19). It is as though Moore first turns his earlier models into shelterers, and then finds them again among the real shelterers in the Underground. Some kind of transformation is going on. These delicate studies are notable, also, for Moore's use of colour and the obvious enjoyment he is getting from the effects of watercolour wash used as background. Without Moore's own captions, however, there would be no reason for us to see these figures as shelterers, and in many cases the titles were invented and added at a much later date, long after the war.

It is a different story with the studies of pairs of figures, miserably trying to protect each other and keep warm, coats and blankets drawn around tired shoulders. Here we are brought face-to-face with the homeless, bombed out inhabitants of the East End, people whom Moore had never encountered before. His notes on the sketch *Three Figures Sleeping* (pl.22) reveal his growing interest in the distorted positions human beings adopt in improvised situations, while conveying the sense of an endless mass of humanity, disappearing into the distance.

19
**Figures for Shelter
Drawing** 1940–41
HMF 1580
pencil, wax crayon,
watercolour wash, pen
and ink
First Shelter Sketchbook
p.22
The British Museum

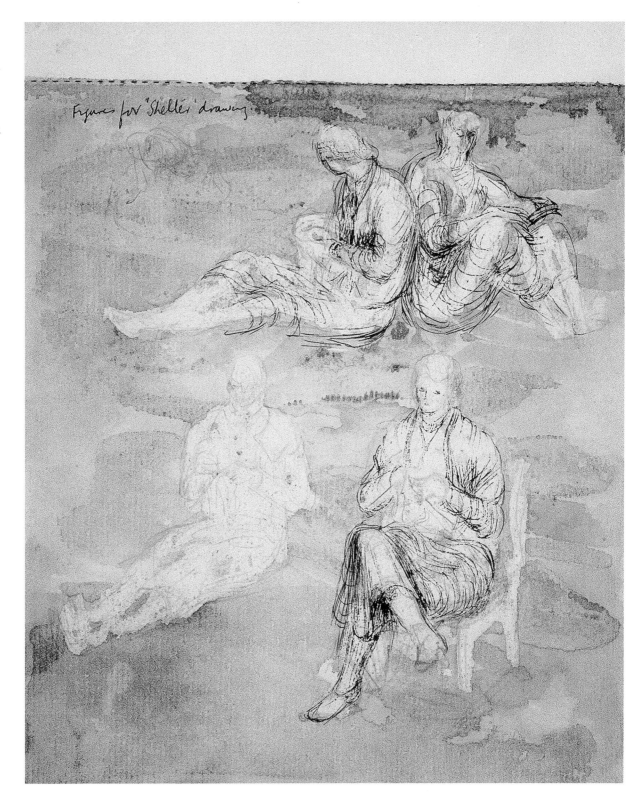

20
Positions of Shelterers
1940–41
HMF 1582
pencil, wax crayon,
watercolour wash, pen
and ink
First Shelter Sketchbook
p.24
The British Museum

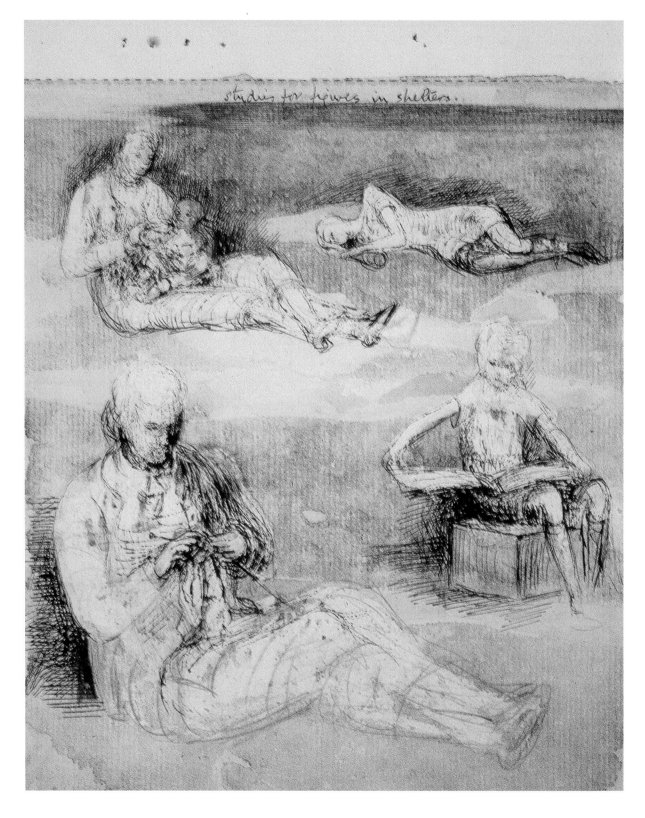

21
**Figure Studies: People
Sharing Blankets**
1940–41
HMF 1647
pencil, wax crayon,
coloured crayon,
watercolour, pen and ink
Second Shelter
Sketchbook p.22
The Henry Moore
Foundation

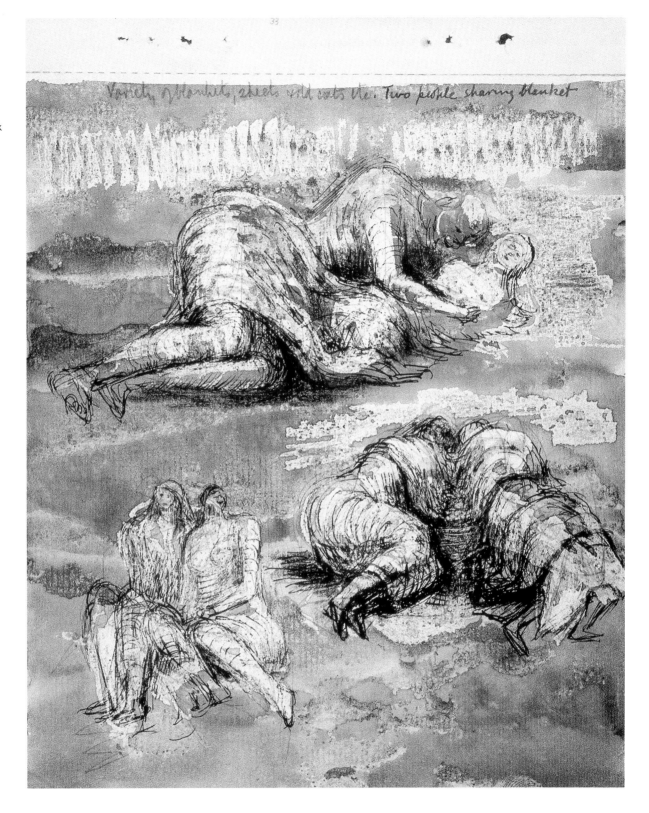

22
Three Figures Sleeping:
Study for Shelter
Drawing
1940–41
HMF 1632
pencil, wax crayon,
watercolour, pen and ink
Second Shelter
Sketchbook p.7
The Henry Moore
Foundation

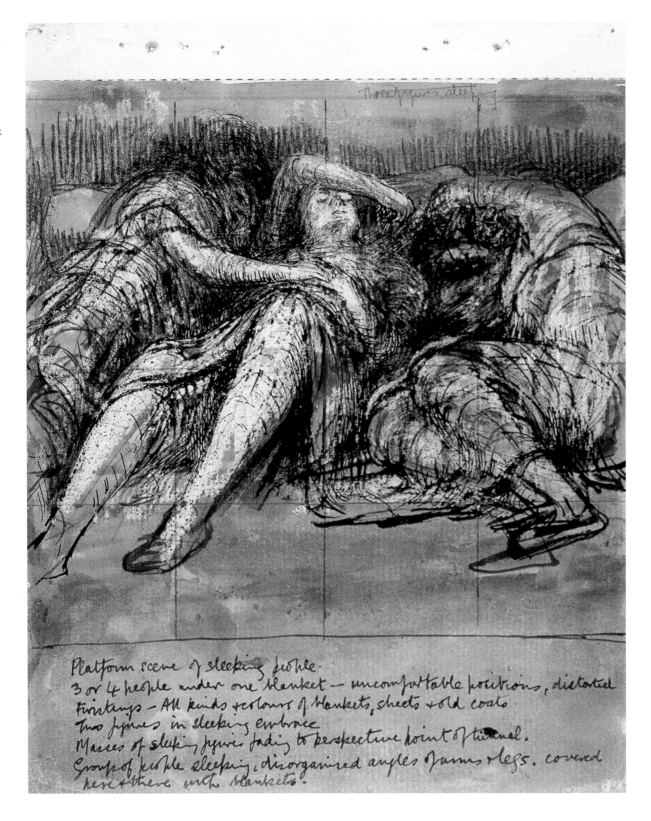

23
**Two Figures Sharing
Same Green Blanket**
1940–41
HMF 1705
pencil, wax crayon,
watercolour, pen and ink
Second Shelter
Sketchbook p.80
The Henry Moore
Foundation

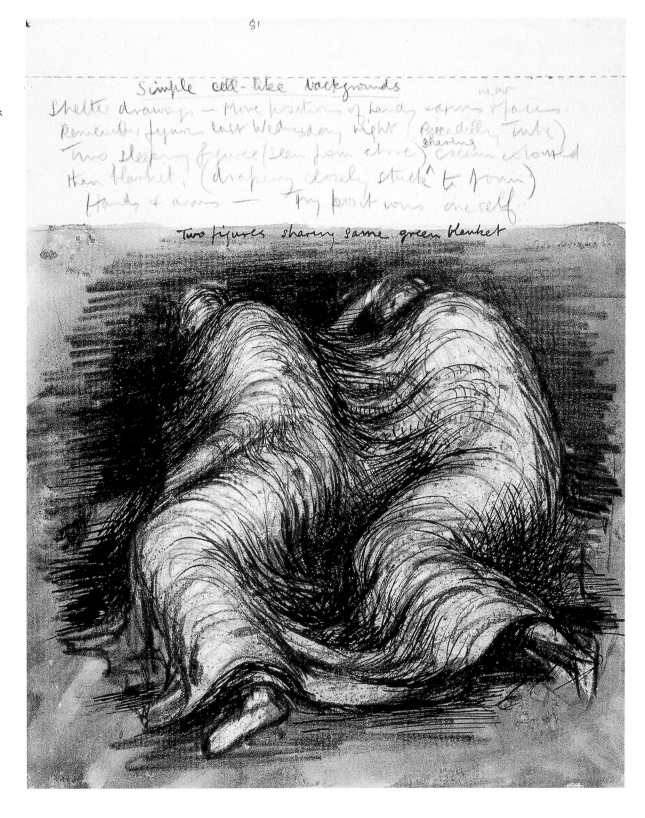

Large Groups in Tube Shelters

With the large groups of shelterers this interest in depth and perspective becomes more marked. Plate 26 shows one of Moore's first versions of the *Tube Shelter Perspective*. The figures are seen from a low angle, giving the viewer the sensation of the tunnel roof curving overhead. Moore's use of heavy dark lines against the patches of colour wash, laid over areas of wax crayon creating a mottled effect, gives a sense of restless movement beneath the coverings of coats and blankets. One can almost smell the warm, fetid air of this tunnel.

The groups of figures that follow are more formally composed. They include versions of several of Moore's favourite themes, the *Mother and Child* and the *Reclining Figure*, placed at contrasting angles to the lines of blanketed figures.

In the *Study for 'Mother and Child among Underground Sleepers'* (pl.28), also shown in its finished version, the emphatically drawn white lines around the figures of the sleepers are an early instance of Moore's sectional line technique. This will be seen, further elaborated, in later drawings. The effect gives a startling, skeletal appearance to the lying bodies, almost as though we are looking at the ribcage of a corpse. Many commentators have pointed out the strong sense of death, burial and decay which seems to emanate from the Shelter Drawings. One wonders whether, even in a fairly hastily executed work like this, Moore was not deliberately contrasting the living foreground figures of the child in its mother's arms with the almost mummified forms behind.

24
Sleeping Figures
1941
HMF 1782
pencil, wax crayon,
coloured crayon,
watercolour wash
290 × 238 mm
The Henry Moore
Foundation

77 Large Groups in Tube Shelters

25
Study for 'Women in a Shelter' 1940–41
HMF 1650
pencil, wax crayon,
coloured crayon,
watercolour wash, pen
and ink
Second Shelter
Sketchbook p.25
The Henry Moore
Foundation

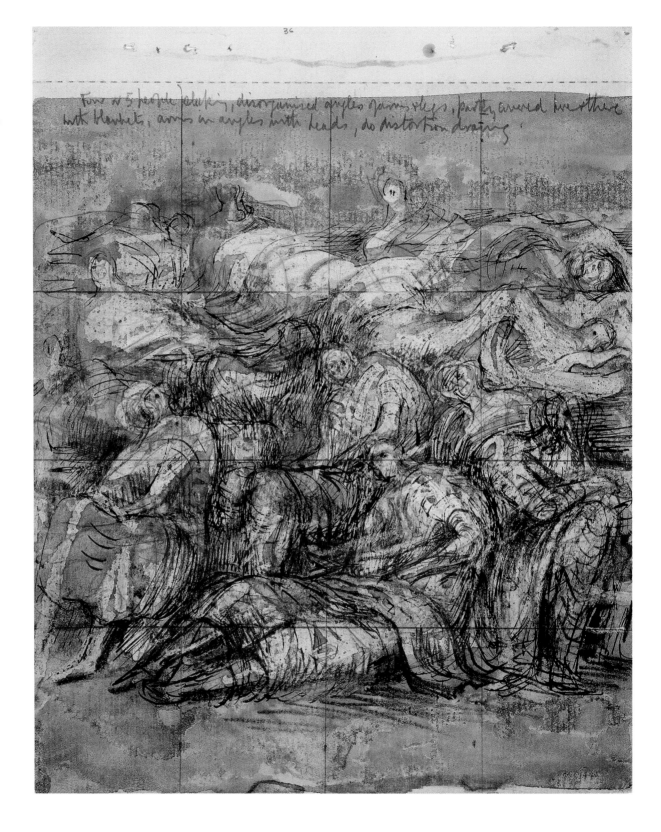

26
Tube Shelter
Perspective 1940–41
HMF 1654
pencil, wax crayon,
coloured crayon,
watercolour wash, pen
and ink
Second Shelter
Sketchbook p.29
The Henry Moore
Foundation

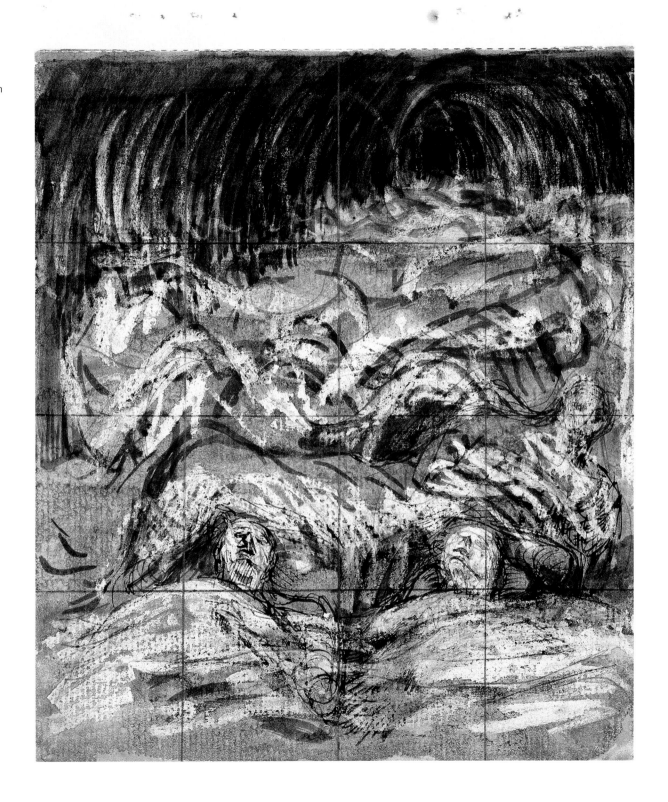

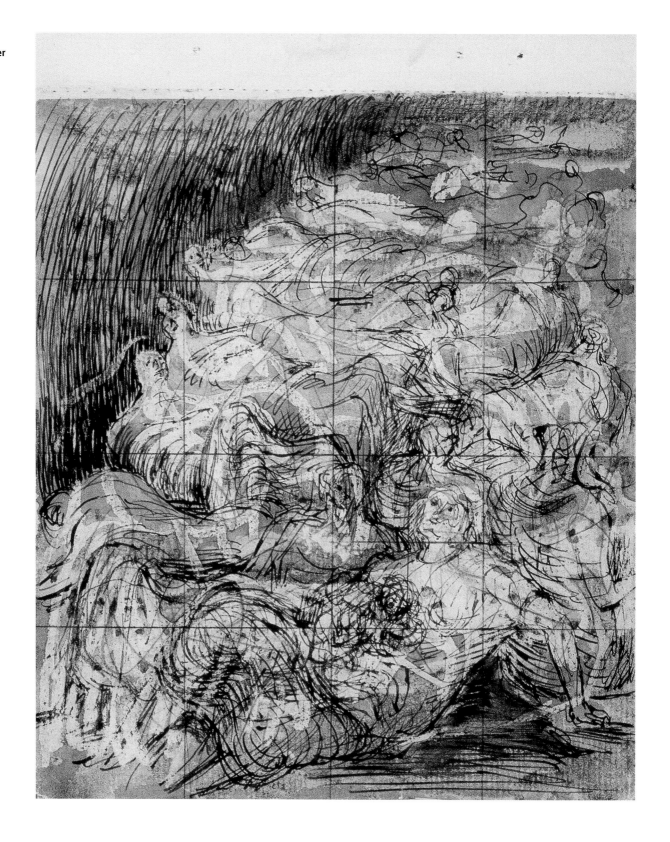

27
Study for 'Pale Shelter Scene' 1940–41
HMF 1656
pencil, wax crayon,
coloured crayon,
watercolour wash
Second Shelter
Sketchbook p.31
The Henry Moore
Foundation

28
**Study for 'Mother and
Child among
Underground Sleepers'**
1940–41
HMF 1645
pencil, wax crayon,
coloured crayon,
watercolour wash, pen
and ink, Conté crayon
Second Shelter
Sketchbook p.20
The Henry Moore
Foundation

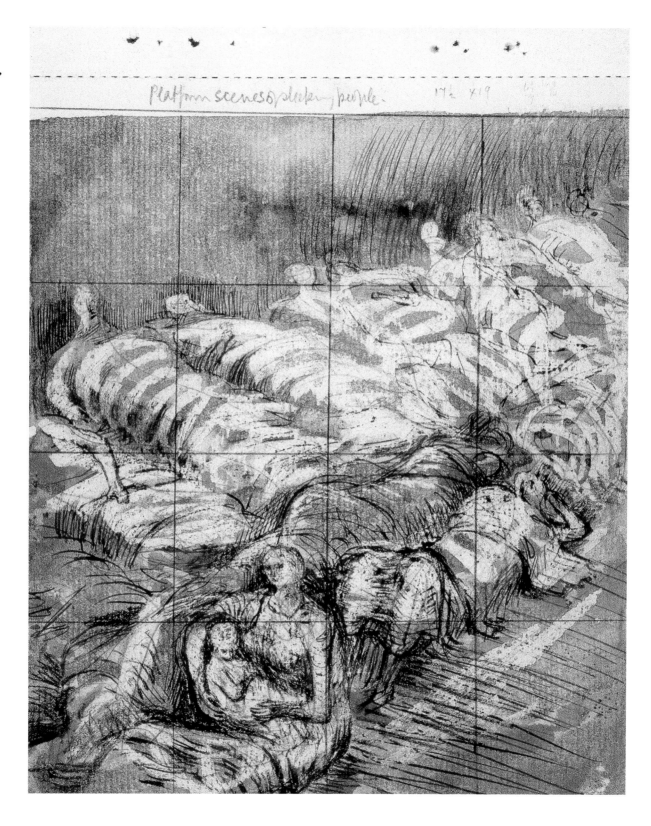

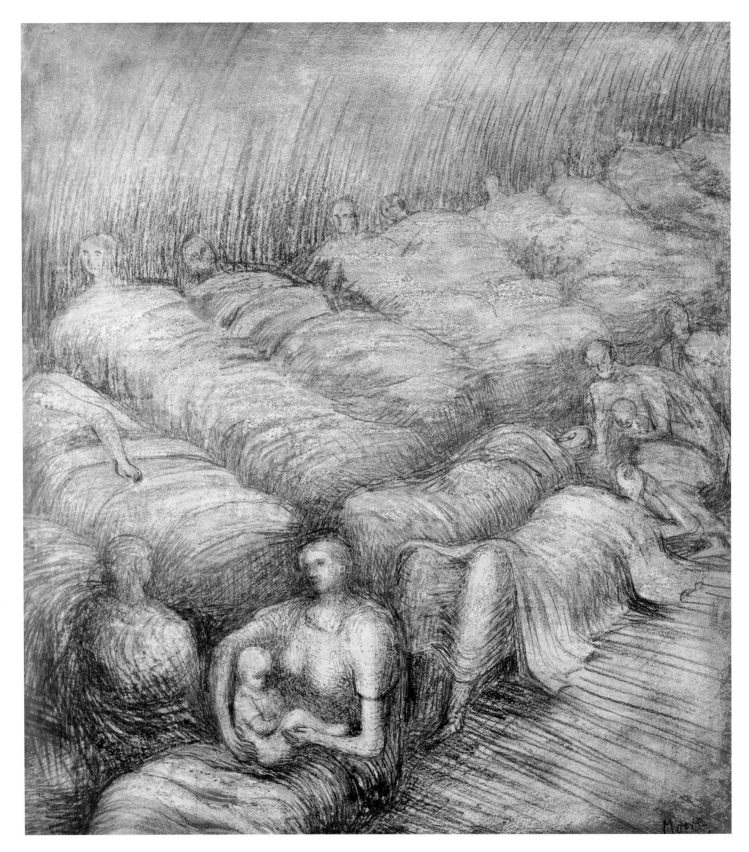

(opposite)
29
**Mother and Child
among Underground
Sleepers** 1941
HMF 1798
pencil, wax crayon,
watercolour wash, pen
and ink, gouache
485 × 439 mm
The Henry Moore
Foundation

30
Women in a Shelter
1941
HMF 1795
pencil, wax crayon,
chalk, watercolour
wash, pen and ink
467 × 432 mm
Museum of London

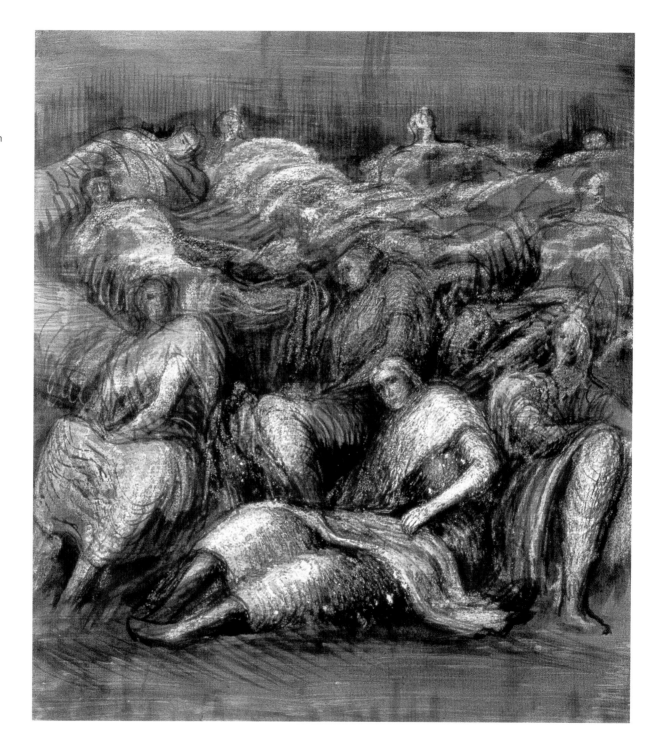

The Sea of Sleepers

As the groups of lying figures grow more extensive so they gradually become depersonalised. In *Group of Shelterers* (pl.31) the top half of the sheet holds half-a-dozen figures, almost all of them outlined with skeletal white lines, so that they resemble bodies found beneath ruins rather than living people. In the lower half of this drawing a large group of figures is merging into an amorphous mass, like some primitive form of life. Further versions of this subject follow.

Moore's title for pl.34, *Sea of Sleepers*, tells us how he was interpreting these scenes. This drawing combines two shelter scenes with a fine figure study of a robed woman, hand on hip. *Shelter Drawing with Sleeping Figures* (pl.36), from the Henry Moore Foundation, is a much freer treatment of the same subject, rapid scribbles of colour highlighting the figures against a dark background, contrast emphasised by use of wax resist, giving a three-dimensional effect.

We then come to two of the finest examples of Moore's use of the sectional line. In *Study for 'Shelter Drawing'* (pl.35) the effect is quite horrific, the figures apparently decaying before our eyes, metamorphosing into grubs or larvae. In *Shadowy Shelter* (pl.37), they have become skeletons sprawled in an abandoned group, powerfully evocative of the mass of bodies unearthed recently at Herculaneum.[25] Do they, perhaps, represent life held in suspension beneath the earth, static, without breath, yet still protected from the violence above? Or, with hindsight, do we see them as a premonition of those terrible scenes of massed corpses revealed to the world in 1945, when the concentration camps were opened?

31
Group of Shelterers
1940–41
HMF 1673
pencil, wax crayon,
coloured crayon,
watercolour wash, pen
and ink
Second Shelter
Sketchbook p.48
The Henry Moore
Foundation

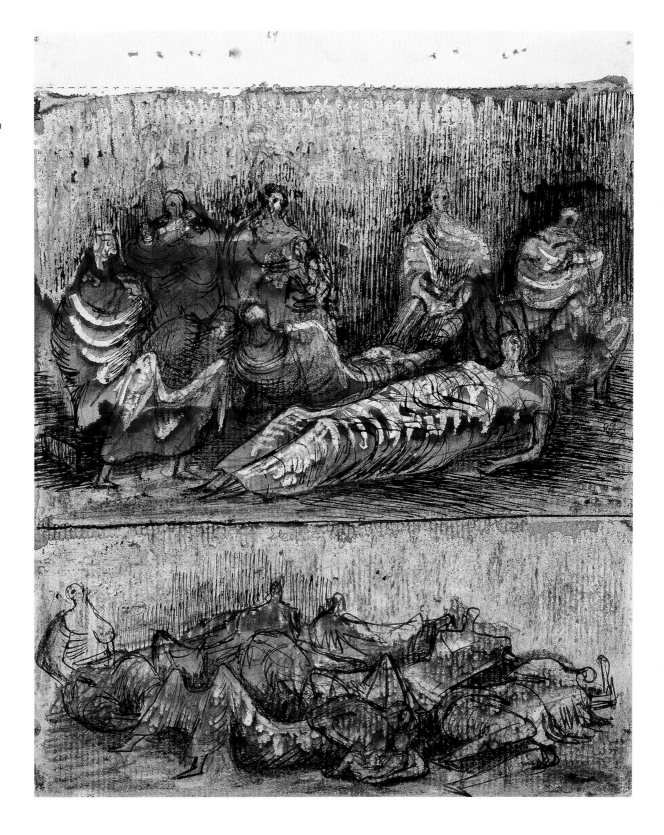

32
Groups of Shelterers
1940–41
HMF 1680
pencil, wax crayon,
coloured crayon,
watercolour wash
Second Shelter
Sketchbook p.55
The Henry Moore
Foundation

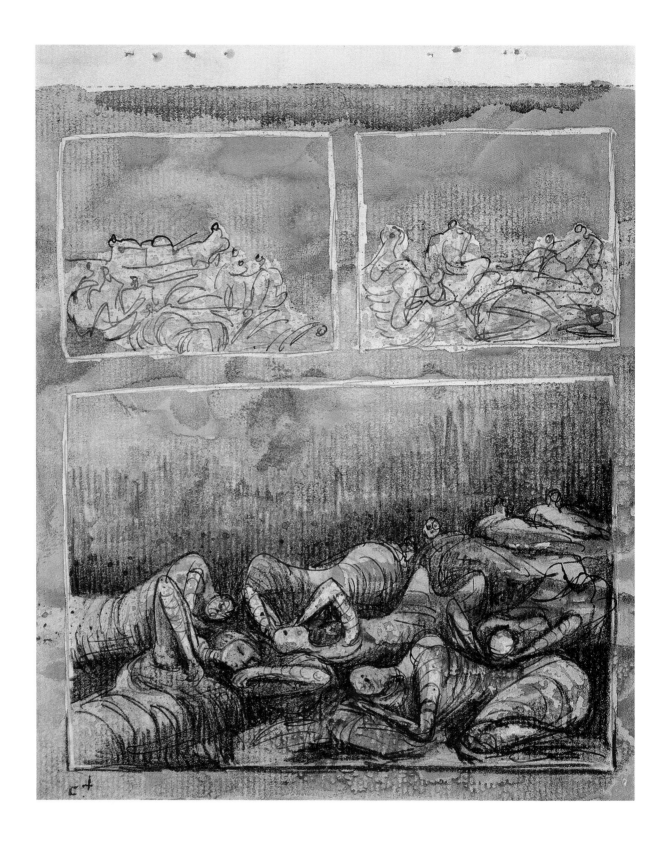

33
Reclining Figures
1940–41
HMF 1615
pencil, wax crayon,
watercolour wash, pen
and ink, gouache
First Shelter Sketchbook
p.57
The British Museum

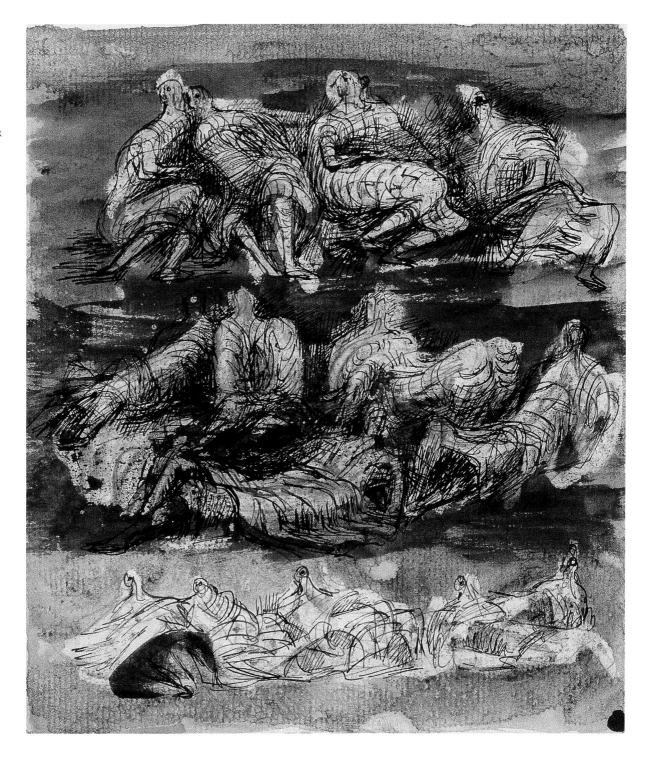

34
Sea of Sleepers 1940–41
HMF 1687
wax crayon, watercolour
wash, pen and ink
Second Shelter
Sketchbook p.62
The Henry Moore
Foundation

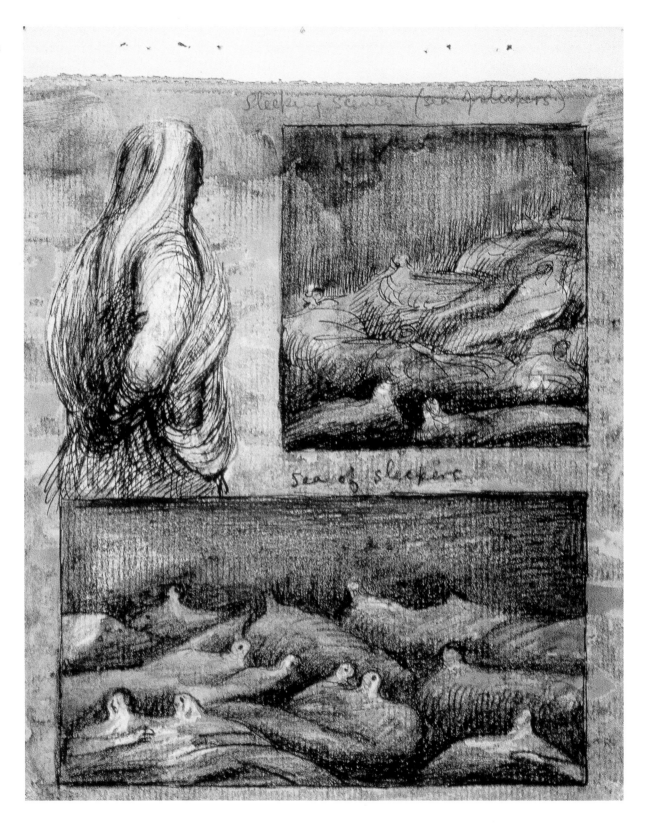

35
Study for 'Shelter Drawing' 1940–41
HMF 1702
pencil, wax crayon,
coloured crayon,
watercolour wash, pen
and ink
Second Shelter
Sketchbook p.77
The Henry Moore
Foundation

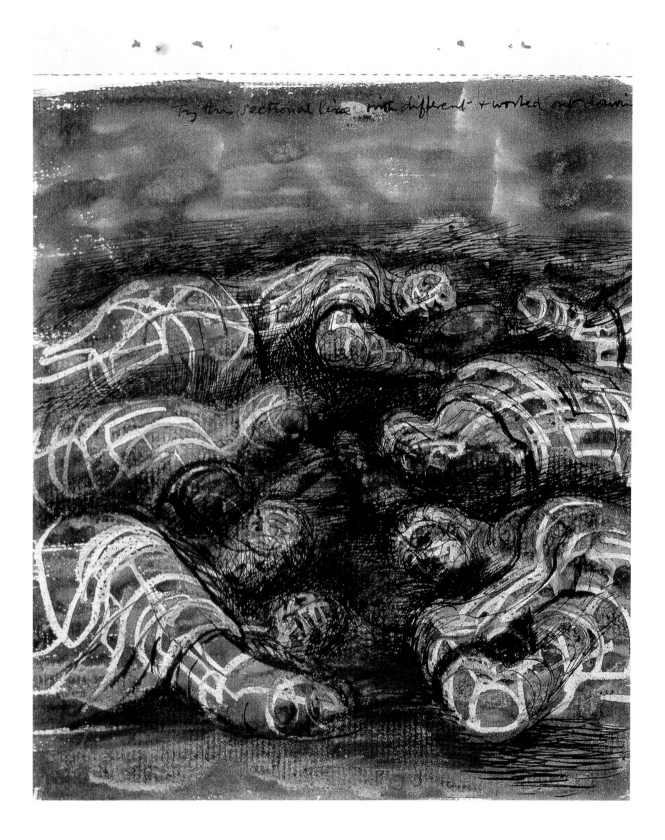

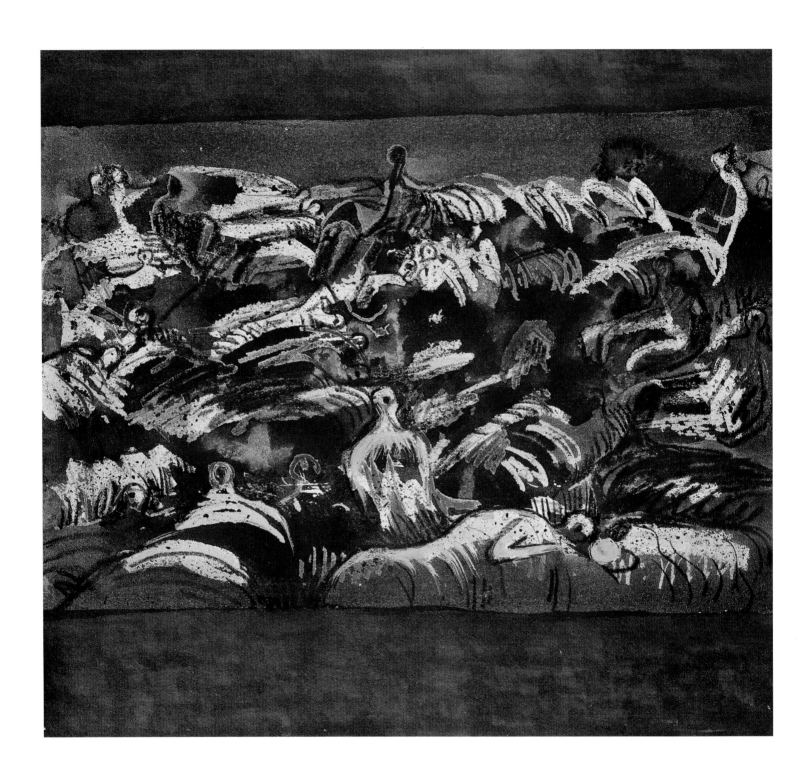

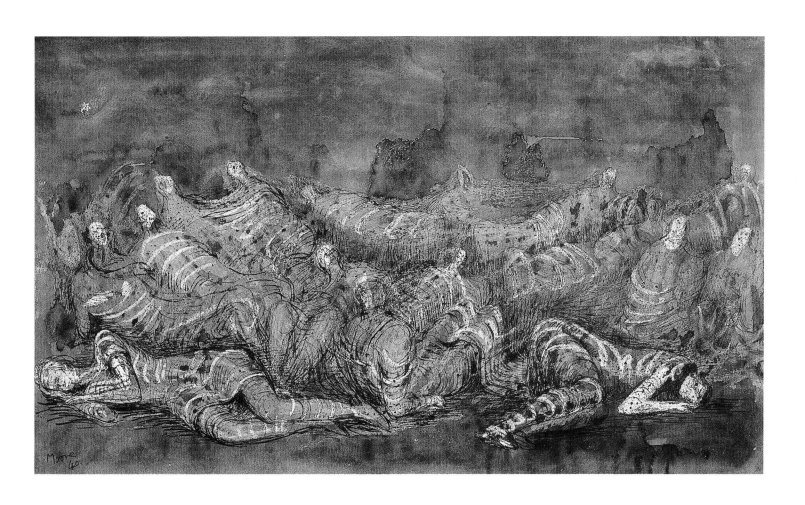

(opposite)
36
**Shelter Drawing with
Sleeping Figures** 1941
HMF 1786
pencil, wax crayon,
coloured crayon,
watercolour wash,
gouache, felt-tipped pen
218 × 238 mm
The Henry Moore
Foundation

37
Shadowy Shelter 1940
HMF 1735
pencil, wax crayon,
chalk, watercolour wash,
pen and ink
260 × 437 mm
Sheffield Galleries and
Museums Trust,
Sheffield

Tube Shelter Perspective

Moore said that the tunnels of the Underground reminded him of the holes in his sculptures. It is easy to see why he was so fascinated by the womb-like

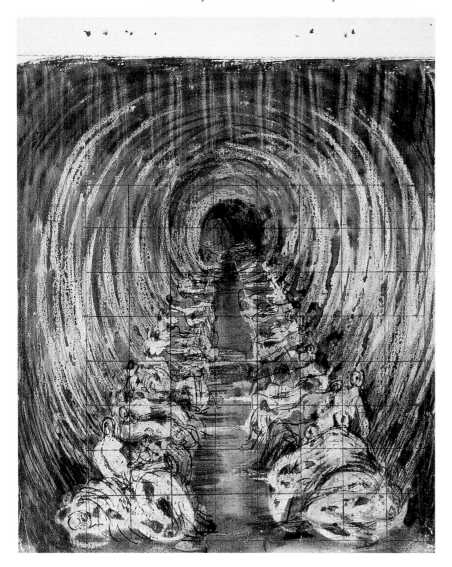

appearance of the Liverpool Street extension, which could hold up to 10,000 shelterers. He produced at least ten variations on this subject, the best-known of his shelter motifs, which has frequently been reproduced, usually from the Tate Gallery version (pl.40). Several of the preliminary versions, however, are more immediate in their effect. This is partly due to interesting variations in colour: the vivid pink used on page 10 of the Second Shelter Sketchbook (pl.38) gives way to pale yellows and chalky whites in later versions. These differences undoubtedly affect one's reading of the image: in plate 38 the warm rosy tone and the fact that many of the figures are sitting up creates a positive impression, as though the tunnel is preserving life which will emerge from this chrysalis once the turmoil above has subsided. But a few pages further on (pl.39) Moore has redrawn the scene, using a grim grey background touched with dingy yellow, creating a sense of hopelessness and decay. In a third version (pl.41) the tonality has been reduced to an almost uniform steely grey touched with white, against a black background. The figures here are reduced to mummified forms.

These drawings have often aroused a sense of unease in viewers, the suggestion of mortality being so pervasive. An early critic, Frederick S. Wight, writing in *The Journal of Aesthetics and Art Criticism* in December 1947, commented that the figures 'have a static life more intense than ours, that is devoid of incident. Their clothes (in the drawings) are cerements. They have the Lazarus look, they are brought like Alcestis from the grave.'

(opposite)
38
Study for 'Tube Shelter Perspective' 1940–41
HMF 1635
pencil, wax crayon,
coloured crayon,
watercolour wash, pen
and ink
Second Shelter
Sketchbook p.10
The Henry Moore
Foundation

39
Tube Shelter Perspective 1941
HMF 1773
pencil, wax crayon,
coloured crayon,
watercolour wash,
gouache
291 × 238 mm
The Henry Moore
Foundation

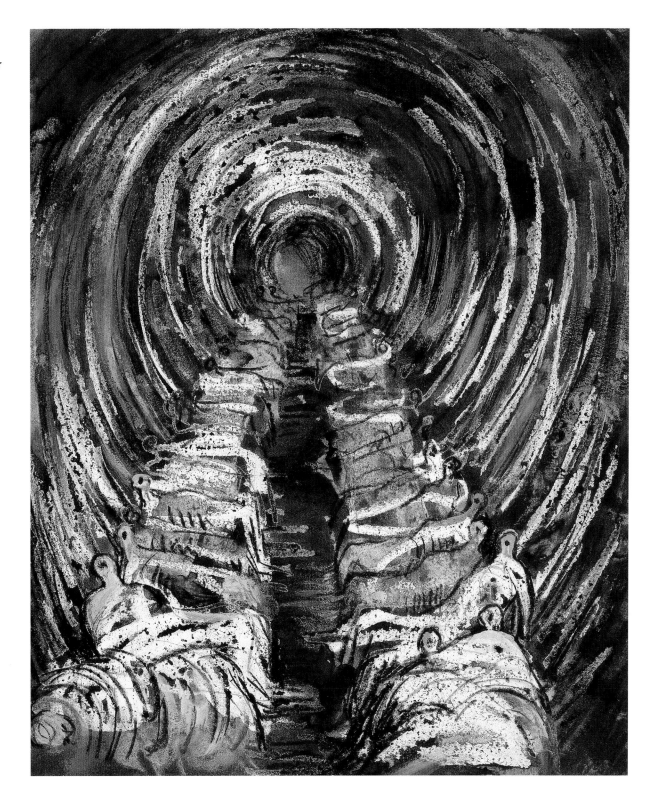

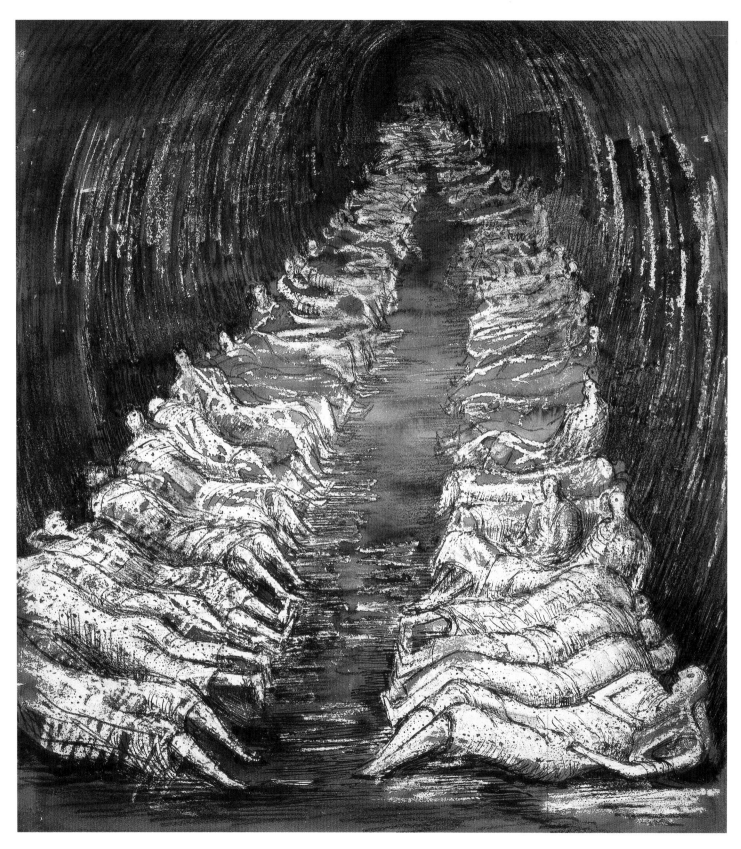

(opposite)
40
**Tube Shelter
Perspective: The
Liverpool Street
Extension**
1941
HMF 1801
pencil, wax crayon,
coloured crayon, chalk,
watercolour wash, pen
and ink
477 × 432 mm
Tate, London

41
**Tube Shelter
Perspective** 1941
HMF 1774
pencil, wax crayon,
coloured crayon,
watercolour wash
291 × 238 mm
The Henry Moore
Foundation

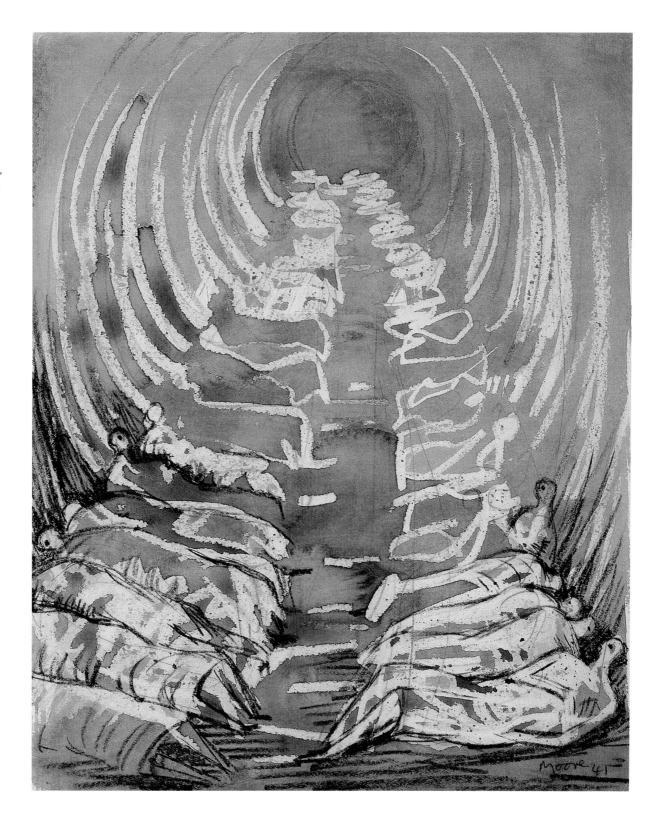

The Tilbury Warehouse Shelter

Three Groups of Shelterers (pl.42) is one of many sketchbook pages that Moore filled after his visits to Tilbury, the cavernous warehouse shelter in the East End. In addition to the vast central space with rows of loading bays, this basement contained small storage rooms and dark corners where families or groups of local friends took up residence. A staircase leading up to the outside is visible in one of these sketches, perhaps the one from which Moore looked out to watch the reflection of flames from burning buildings nearby. There is a sense of grime and odour about these scenes. A large number of the single figures who recur in the sketchbooks, such as the old woman in a hat, were people Moore saw and remembered from Tilbury.

Tilbury Shelter: Group of Draped Figures, from the Hiroshima Museum of Art (pl.45), is one of the most highly worked-up drawings in the whole series. On the left the receding verticals of a line of loading bays create a sense of depth. Against these, on the opposite side, are the horizontals of huge rolls of paper, still stored in the warehouse while it was being used as a shelter. More of these are visible end-on at the back. In the foreground three monumental figures, one holding a child, sit passively. They seem oblivious to the chaotic scenes behind them, where hundreds of reclining figures are spread out, filling the entire floor area in a hellish confusion. Shafts of light illuminate parts of the background, which has something of the atmosphere of an apocalyptic scene by Piranesi or John Martin. The combination of vast space with a simultaneous sense of claustrophobia is disturbing.

The figures in *Study for Two Women Wrapped in Blankets* (pl.46) are totally different from the neatly dressed, presentable ladies Moore used as models in his first shelter sketches. This heavy exhausted pair, blankets round their shoulders, are clearly people from the East End. On the back wall, in several of these scenes, ragged paper notices have been pinned up. These are the shelter rules, not an edict from faceless bureaucrats in a Ministry, but practical instructions drawn up by the impromptu shelter committees that formed spontaneously, trying to bring some order to the chaos. Occasionally large painted numbers also appear, identifying the separate bays.

Woman Seated against Bomb-Scarred Wall and *Half-Length Standing Woman in Front of Wall* (pls 48 & 49) are two of a number of studies of the same woman, seated in the Tilbury shelter. This little sequence ends with a transformation: the woman turns into the wall itself in the surprising *Head Made up of Devastated House* (pl.50), a Picasso-like touch.

42
**Three Groups of
Shelterers**
1940–41
HMF 1595
pencil, wax crayon,
coloured crayon,
watercolour wash, pen
and ink
First Shelter Sketchbook
p.37
The British Museum

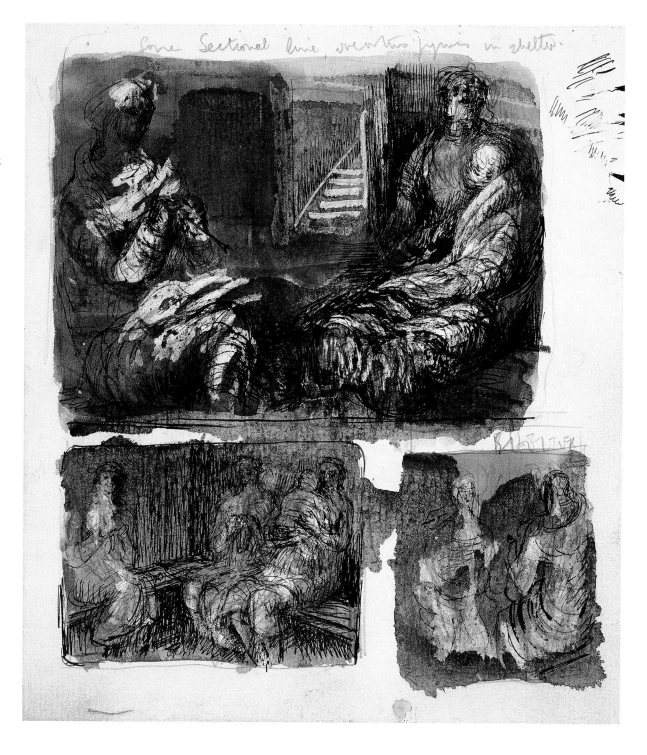

43
**In a Large Public
Shelter** 1940–41
HMF 1592
pencil, wax crayon,
coloured crayon,
watercolour wash, pen
and ink
First Shelter Sketchbook
p.34
The British Museum

(opposite)
44
Tilbury Shelter Scene
1941
HMF 1800
pencil, wax crayon, pen
and ink, wash, gouache
425 × 381 mm
Tate, London

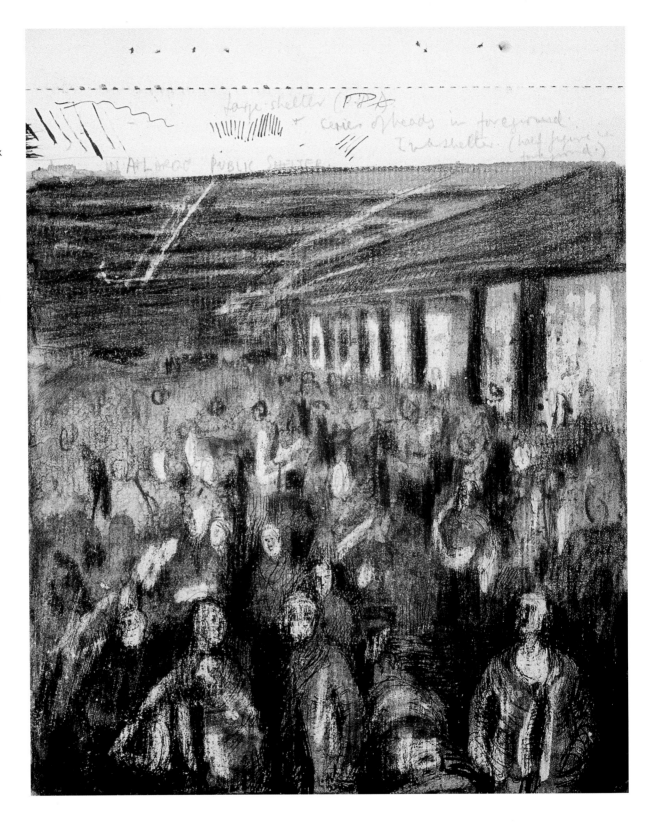

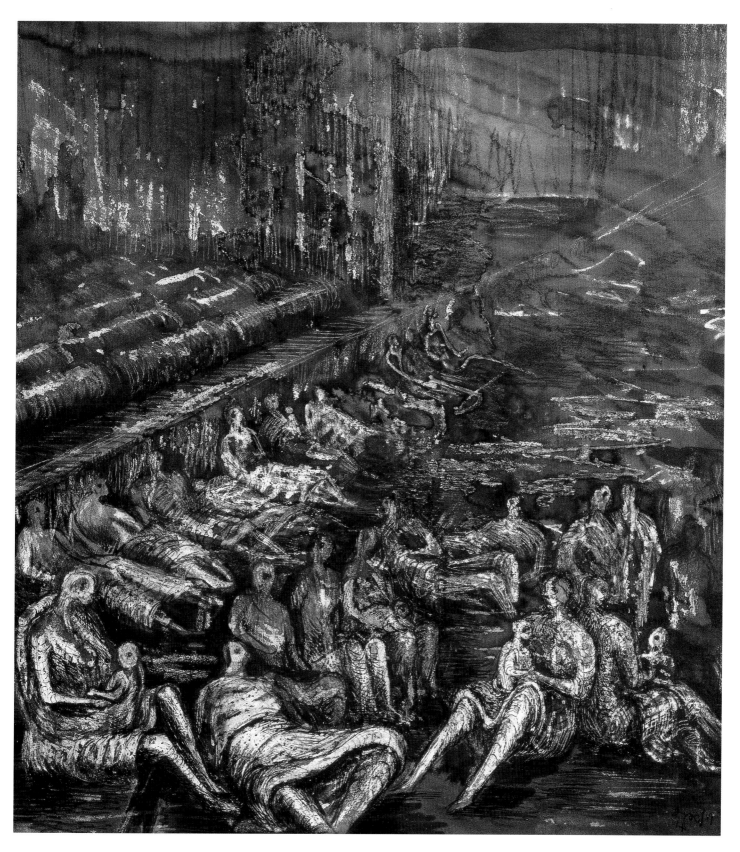

99 The Tilbury Warehouse Shelter

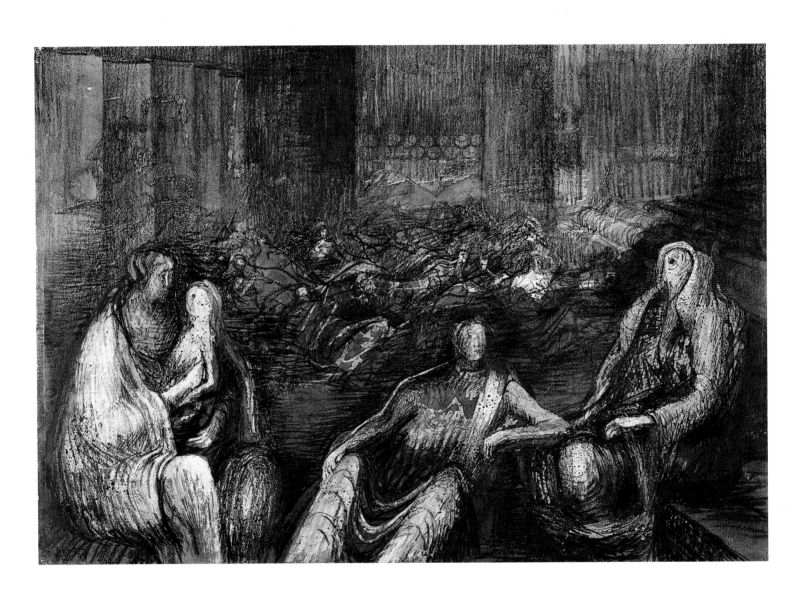

45
**Tilbury Shelter: Group
of Draped Figures** 1941
HMF 1817
pencil, wax crayon,
watercolour wash, pen
and ink, gouache
381 × 559 mm
Hiroshima Prefectural
Art Museum, Hiroshima

46
**Study for two Women
Wrapped in Blankets**
1940–41
HMF 1691
pencil, wax crayon,
watercolour, pen and ink
Second Shelter
Sketchbook p.66
The Henry Moore
Foundation

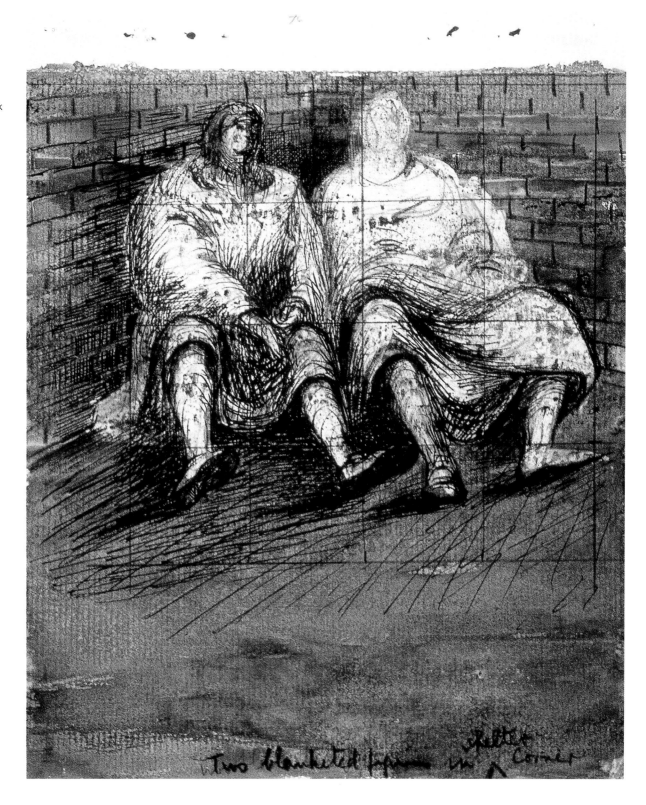

47
Four Shelterers 1940–41
HMF 1597
pencil, wax crayon,
coloured crayon,
watercolour wash, pen
and ink
First Shelter Sketchbook
p.39
The British Museum

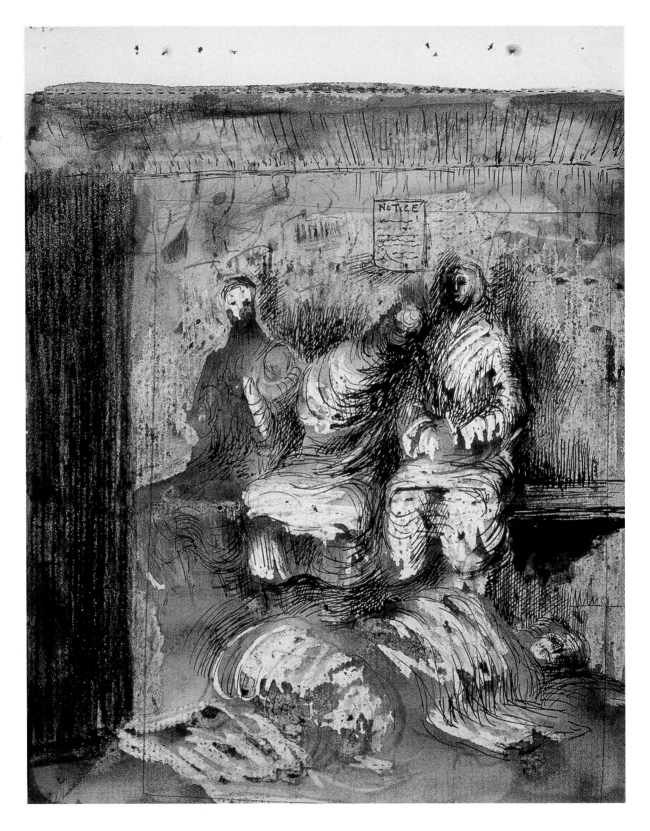

48
**Woman Seated against
Bomb-Scarred Wall**
1940–41
HMF 1607
pencil, wax crayon,
coloured crayon,
watercolour wash, pen
and ink, gouache
First Shelter Sketchbook
p.49
The British Museum

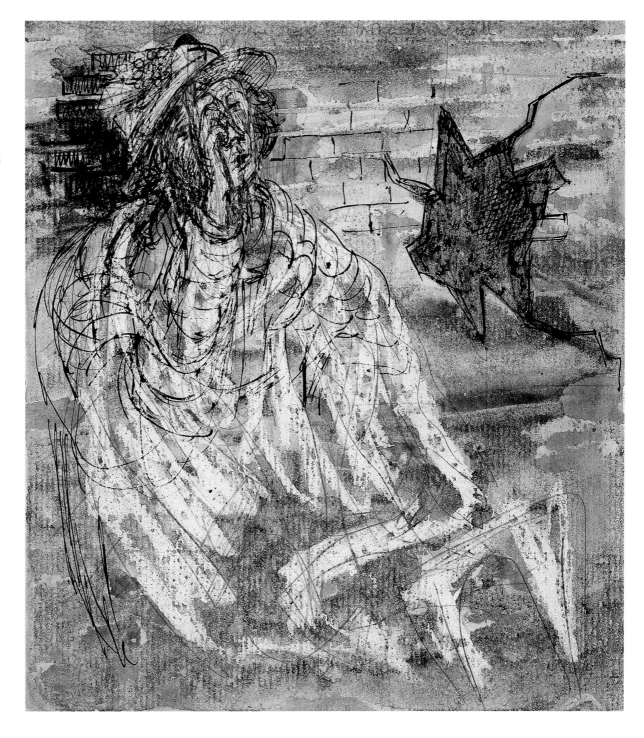

49
**Half-Length Standing
Woman in front of Wall**
1940–41
HMF 1608
pencil, wax crayon,
coloured crayon,
watercolour wash, pen
and ink
First Shelter Sketchbook
p.50
The British Museum

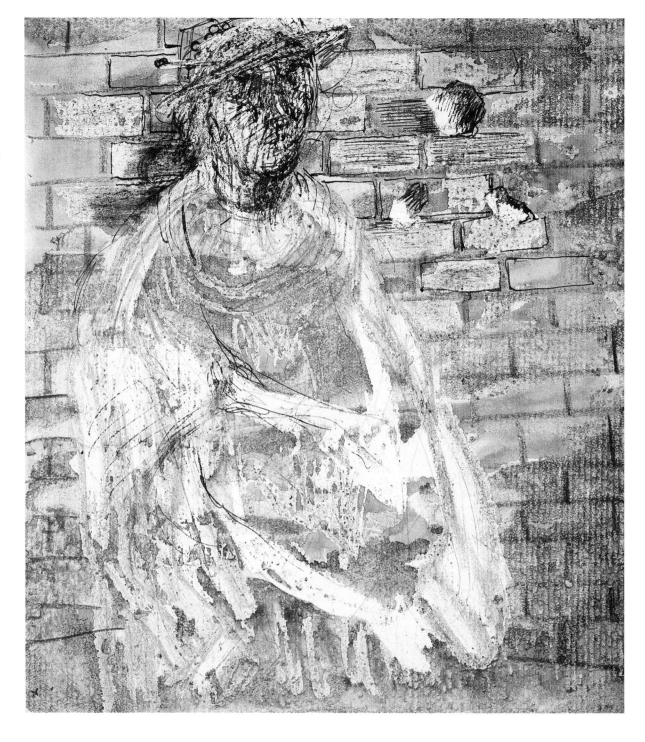

50
**Head Made up of
Devastated House**
1940–41
HMF 1611
pencil, wax crayon,
coloured crayon,
watercolour wash, pen
and ink
First Shelter Sketchbook
p.53
The British Museum

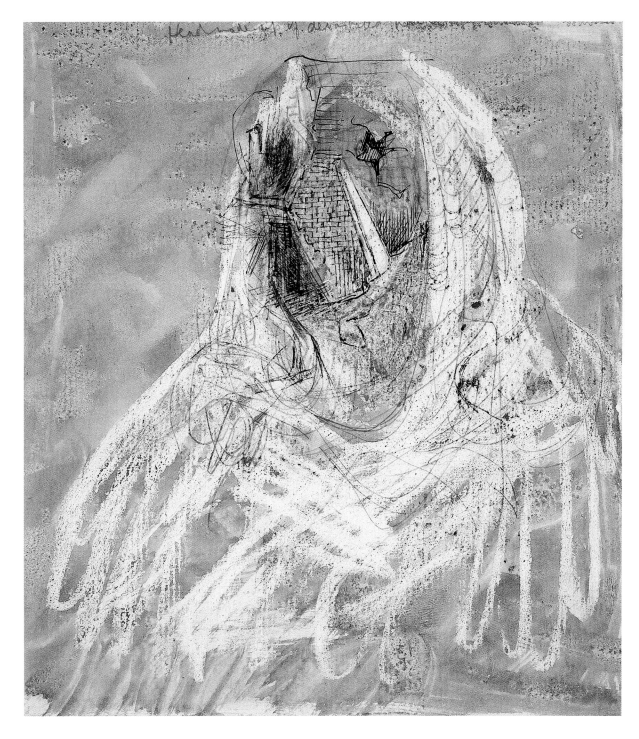

Multiple Studies of Single Figures

As he moved through the shelters Moore noticed
individual figures among the crowds, figures that
stood out from the rest by reason of a particular
position or attitude – for a sculptor a pose, in fact,
like the pose adopted by a model in the studio. Many
sketchbook pages were now filled with multiple
studies of such figures, first scribbled hastily in
pencil and then worked over the following day in a
variety of media. His practice of putting down many
variations on the same theme on one piece of paper
had been developed during the 1930s, though his
subjects then were mainly ideas for abstract
sculptures. Now he was back, facing the infinite
variety of poses the human figure could adopt, with
the added dimension of pathos. Many of the people
he sketched were exhausted, often clinging to the
blankets or coats which were their only possessions.
A shawl draped around shoulders, the sagging pull of
a blanket stretched across knees, these many-
coloured coverings seemed, simultaneously, to
reveal as well as conceal the figure crouched
beneath. At the same time, we become aware of
Moore's growing interest in exploring the uses of
strong colour, something that had begun to appear in
his drawings just before the outbreak of war.

On many of these pages we can find human forms
metamorphosing into sculptures – or the other way
round – while a drawing such as *People Wrapped in
Blankets* (pl.55), from the First Shelter Sketchbook,
gives us a preview of the hieratic seated figures,
characters who will appear in the last major drawings
of the series.

51
Shelter Drawing
1940–41
HMF 1671
pencil, wax crayon,
coloured crayon,
watercolour wash, pen
and ink
Second Shelter
Sketchbook p.46
The Henry Moore
Foundation

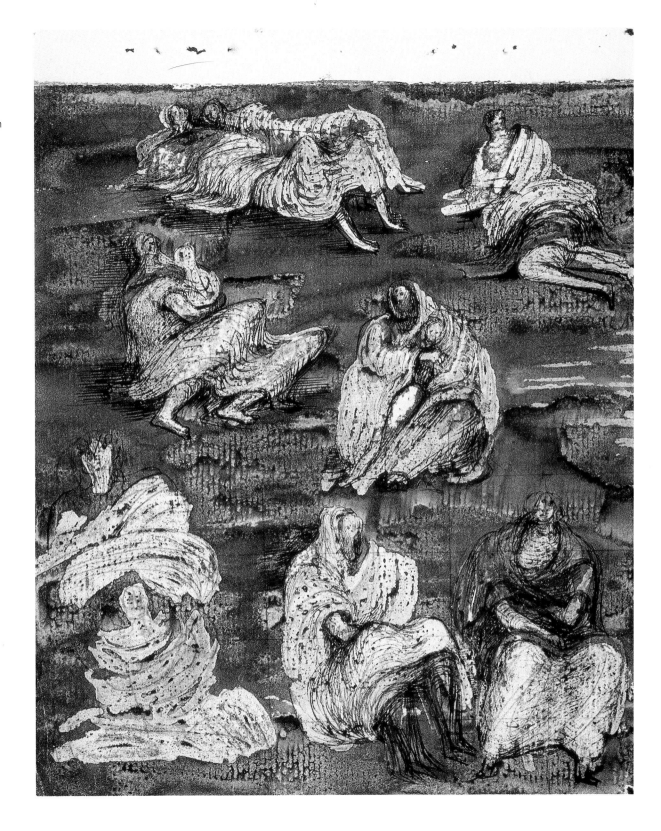

52
Shelter Scene 1940–41
HMF 1659
pencil, wax crayon,
coloured crayon,
watercolour wash, pen
and ink
Second Shelter
Sketchbook p.34
The Henry Moore
Foundation

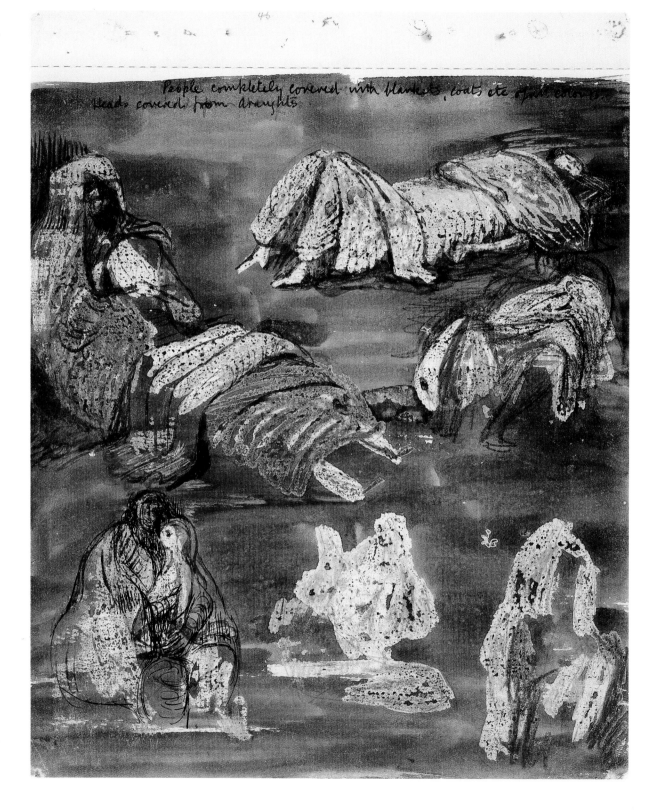

53
Study for 'Group of Draped Figures in an Shelter' 1940–41
HMF 1672
pencil, wax crayon, coloured crayon, chalk, wash, pen and ink
Second Shelter Sketchbook p.47
The Henry Moore Foundation

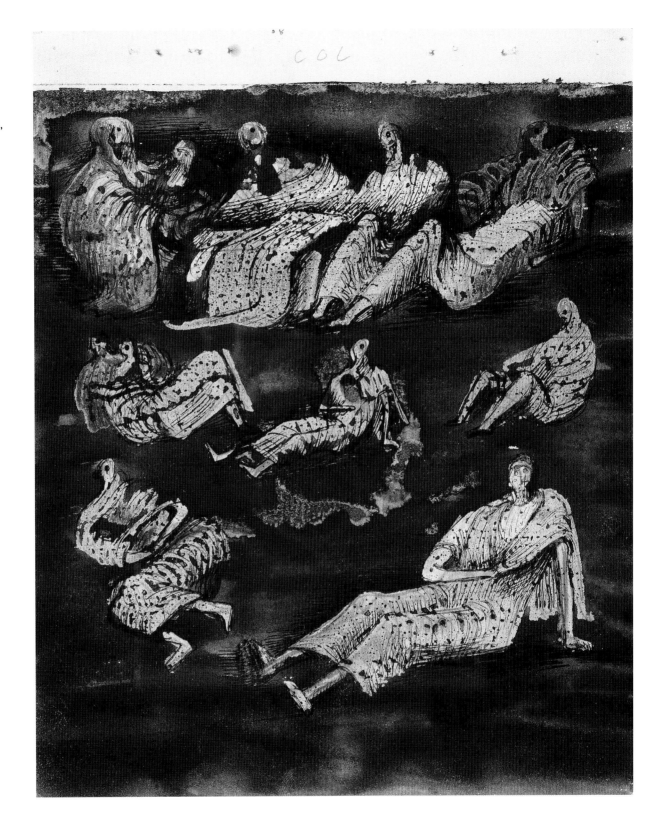

54
**Studies for 'Tube
Shelter Scene' and
'Figure in a Shelter'**
1940–41
HMF 1676
pencil, wax crayon,
coloured crayon,
watercolour wash, pen
and ink
Second Shelter
Sketchbook p.51
The Henry Moore
Foundation

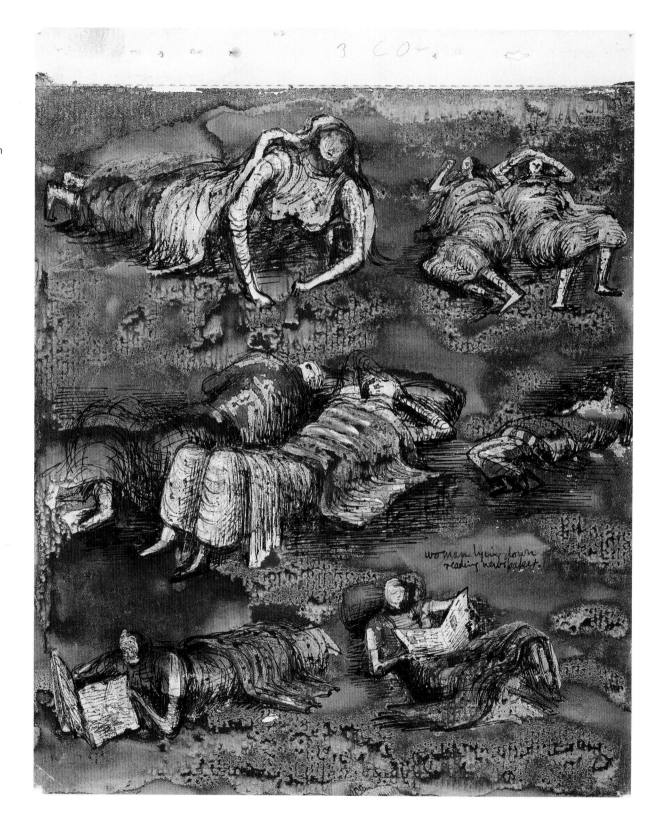

55
**People Wrapped in
Blankets** 1940–41
HMF 1619
pencil, wax crayon,
watercolour wash, pen
and ink
First Shelter Sketchbook
p.61
The British Museum

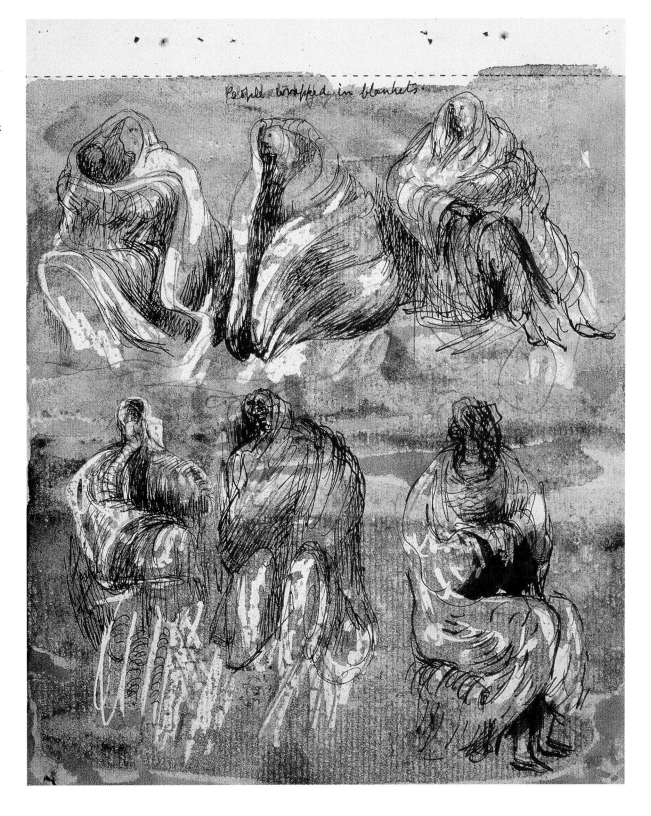

Bunks and Sleepers

Moore often said it was the disorganised atmosphere of the shelters that interested him, and that when the authorities began tidying things up, putting in bunks and so on, his interest began to wane. Even so, he made a great many sketches of the three-tier bunks which extended along the whole length of the platform in some of the stations. He seems to have been attracted by the contrast between the formal rectangles of the bunks with their supporting struts, and the soft, rounded forms of the sleepers lying on them. Hanging coats sometimes appear, ghostly presences in themselves, while the occasional use of cord, threaded in a zigzag on the outside of a middle bunk to prevent the occupant from falling out, is reminiscent of the stringed figures he constructed at the end of the 1930s.

In several of these drawings he contrasts seated or lying figures on the ground, in front of the bunks, with the shrouded, horizontal forms above them. Finally in this group, as in some of the multiple studies, we see him experimenting with fast, scribbled blocks of colour that have been dashed off as exercises in virtuosity, but which still evoke the awkward cramped conditions.

56
Study for 'Shelter Scene: Bunks and Sleepers' 1940–41
HMF 1658
pencil, wax crayon, coloured crayon, wash, pen and ink
Second Shelter Sketchbook p.33
The Henry Moore Foundation

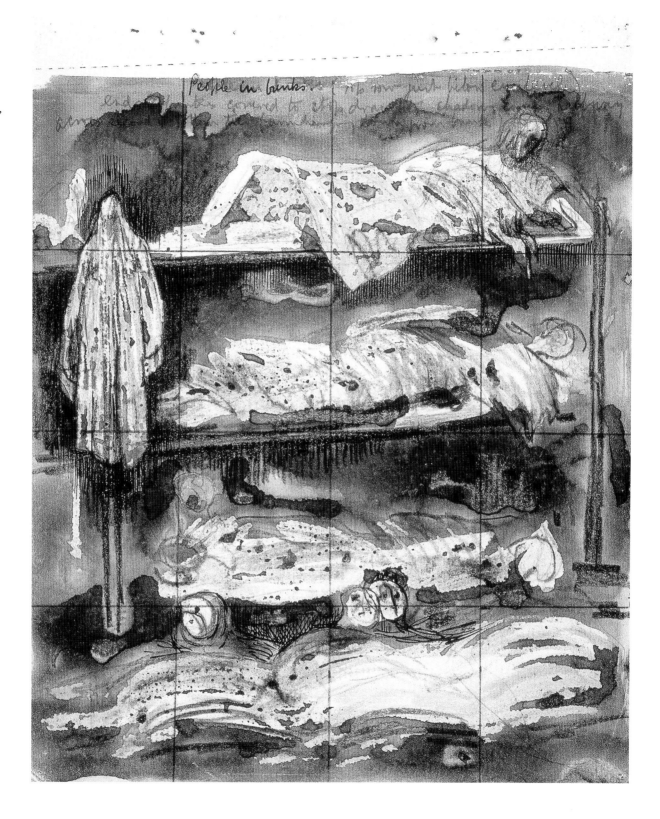

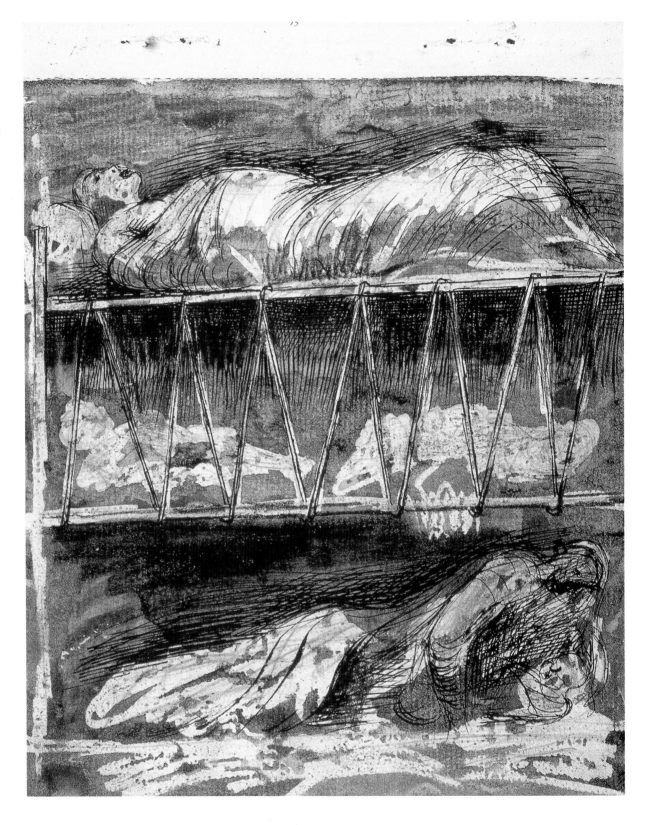

57
Study for 'Shelter Scene: Bunks and Sleepers' 1940–41
HMF 1699
pencil, wax crayon, coloured crayon, watercolour, pen and ink
Second Shelter Sketchbook p.74
The Henry Moore Foundation

58
Shelter Scene: Bunks and Sleepers *c.*1941
HMF 1791
pencil, wax crayon, coloured crayon, watercolour wash, pen and ink
263 × 192 mm
Private collection, USA

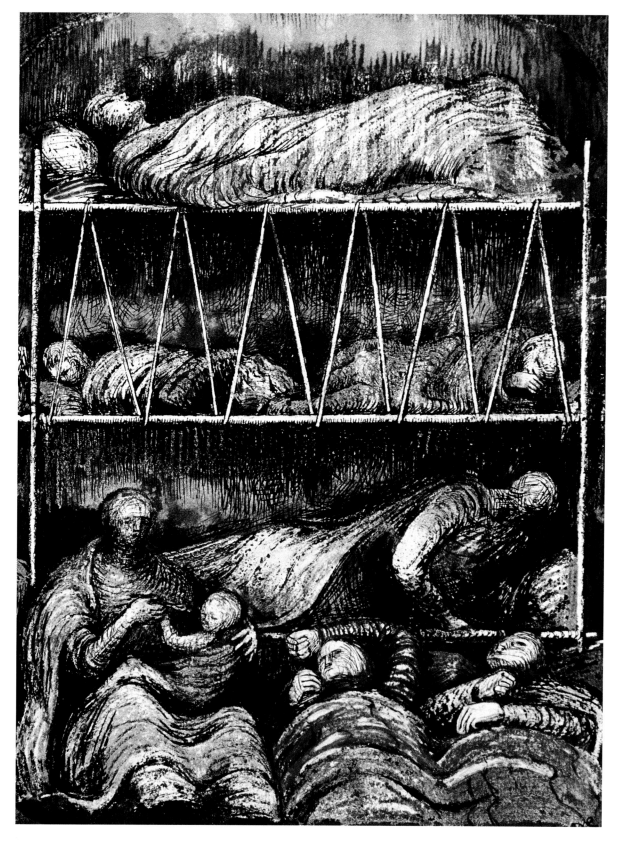

59
Bunks and Sleepers
1940–41
HMF 1697
pencil, wax crayon,
coloured crayon,
watercolour wash, pen
and ink
Second Shelter
Sketchbook p.72
The Henry Moore
Foundation

60
**Study for 'Shelter
Scene: Bunks and
Sleepers'** 1940–41
HMF 1663
pencil, wax crayon,
coloured crayon,
watercolour wash, pen
and ink
Second Shelter
Sketchbook p.38
The Henry Moore
Foundation

Sleeping Positions

A sleeping person may unconsciously adopt a position which looks awkward, even uncomfortable, particularly if he or she is lying on a hard surface. Such was the lot of most of the shelterers, so it is not surprising that an artist, observing exhausted people, should have noticed oddities in the way they lay. Elbows, in particular, can be a nuisance, and get in the way at the best of times when people are sleeping together.

In these drawings Moore is observing the visual effects produced when a lot of sleeping figures are crowded up against each another. There is simply no room for all the elbows. They don't fit under the blankets and have to be wound around the head or stretched across a neighbour in a confusion of odd angles. Drawings such as *Study for 'Sleeping Positions'* (pl.62) and *Sleeping Figures* (pl.61) were based on scenes in the Tilbury shelter. In them Moore highlights the white of arms and elbows standing out against the amorphous dark of assorted coverings.

Shelter Drawing: Sleeping Figures (pl.65) from the Henry Moore Foundation's collection, and *Four Grey Sleepers* (pl.67), which Wakefield Art Gallery received from the WAAC, are two of the finest drawings in the whole series. The second of these is shown together with its preliminary sketch, enabling the viewer to follow both the squaring-up process and the decisions Moore took on what to leave out when composing the final drawing.

It has been pointed out, though, that the sleep of the figures in these drawings can be read as something deeper than the oblivion that comes from total exhaustion. There are disturbing echoes, yet again, of burial and decay and the sense of a

presentiment mentioned in connection with the skeletal drawings seen earlier, notably *Shadowy Shelter* (pl.37).

61
Sleeping Figures
1940–41
HMF 1683
pencil, wax crayon,
coloured crayon,
watercolour wash, pen
and ink
Second Shelter
Sketchbook p.58
The Henry Moore
Foundation

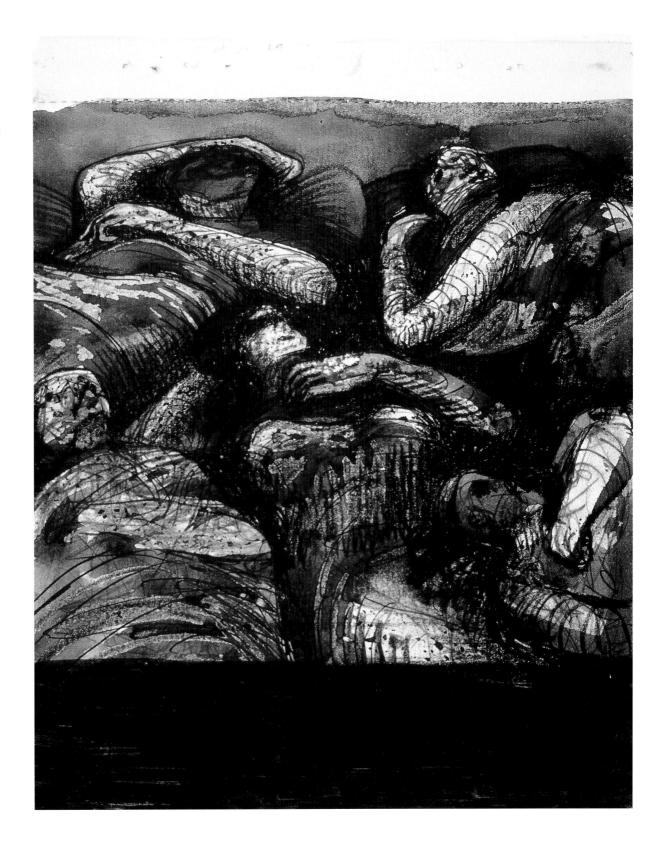

62
62
Study for 'Sleeping Positions' 1940–41
HMF 1681
pencil, wax crayon, coloured crayon, watercolour wash, pen and ink
Second Shelter Sketchbook p.56
The Henry Moore Foundation

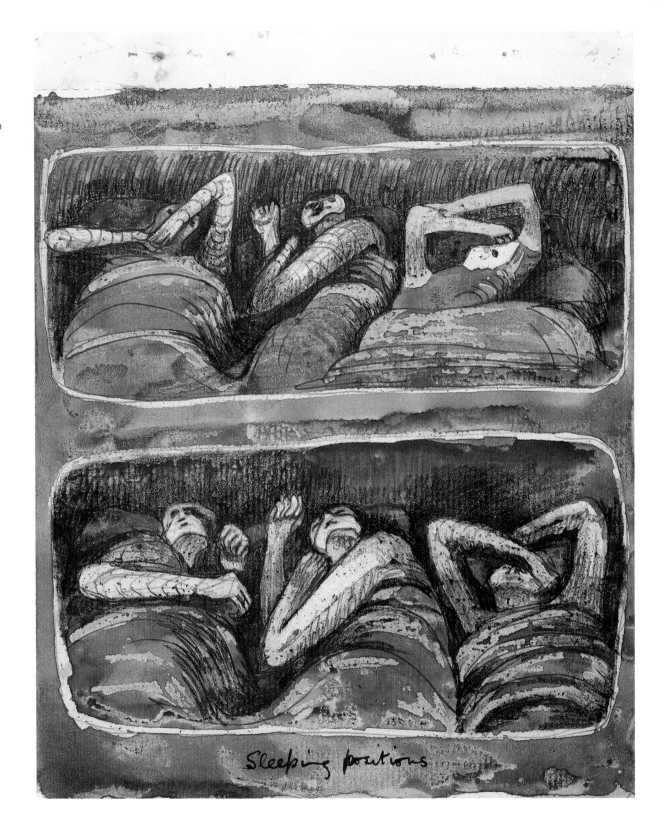

63
Dozing Shelterers
1940–41
HMF 1710
pencil, wax crayon,
coloured crayon,
watercolour wash
Second Shelter
Sketchbook p.85
The Henry Moore
Foundation

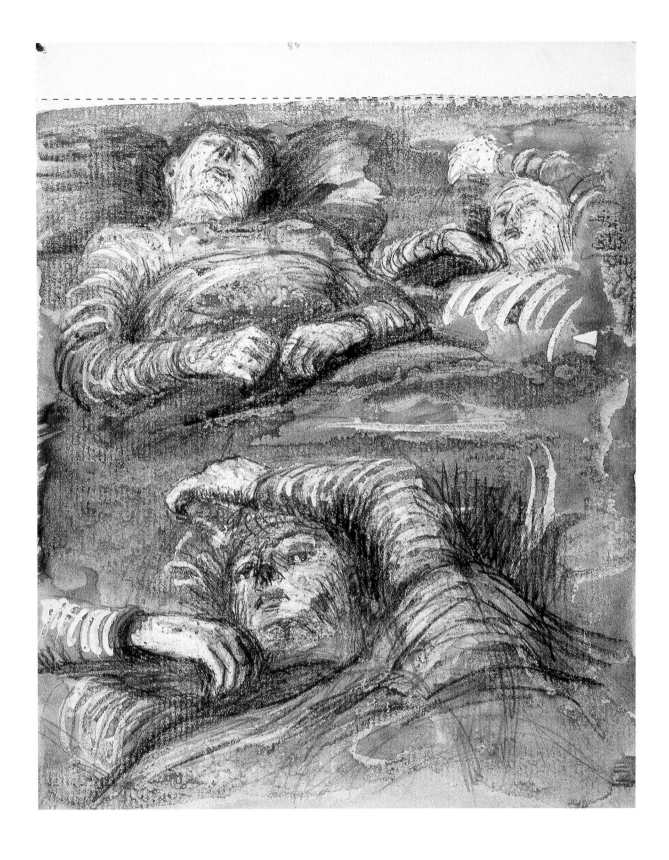

64
Fitful Sleepers 1940–41
HMF 1704
pencil, wax crayon,
coloured crayon,
watercolour wash, pen
and ink
Second Shelter
Sketchbook p.79
The Henry Moore
Foundation

(opposite)
65
Shelter Drawings:
Sleeping Figures 1941
HMF 1816
pencil, wax crayon,
watercolour wash, pen
and ink
303 × 308 mm
The Henry Moore
Foundation

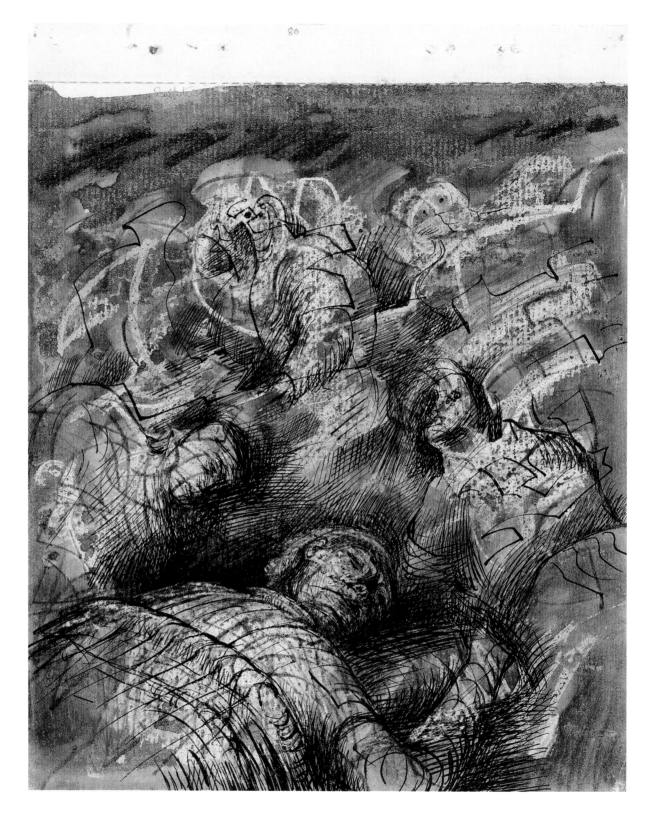

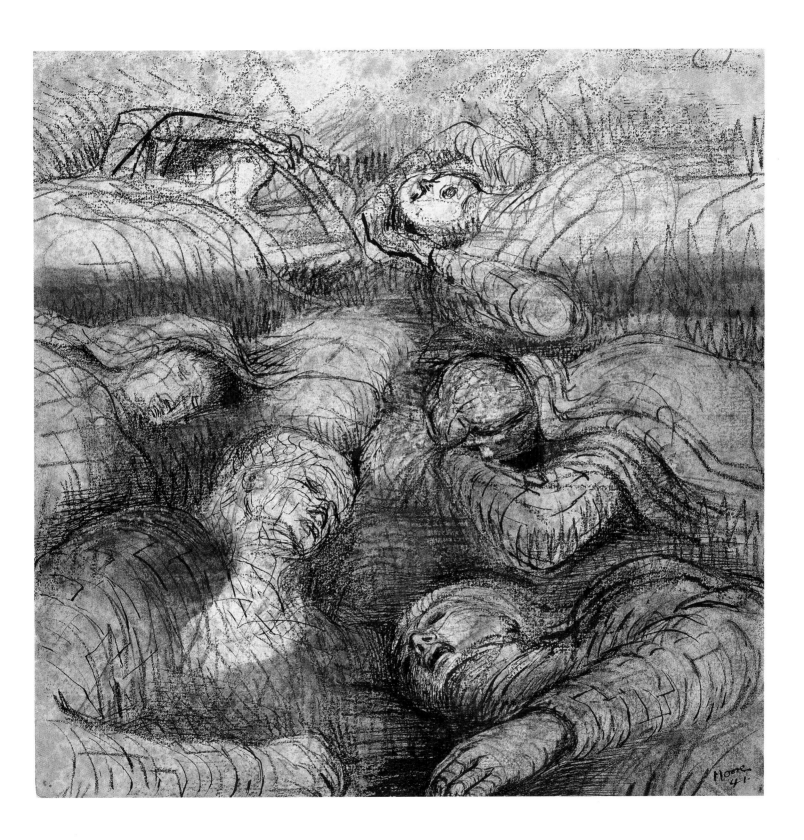

66
Study for 'Four Grey Sleepers' 1940–41
HMF 1703
pencil, wax crayon,
coloured crayon,
watercolour wash, pen
and ink
Second Shelter
Sketchbook p.78
The Henry Moore
Foundation

(opposite)
67
Four Grey Sleepers 1941
HMF 1847
pencil, wax crayon,
watercolour wash, pen
and ink
425 × 502 mm
Wakefield MDC
Museums and Arts

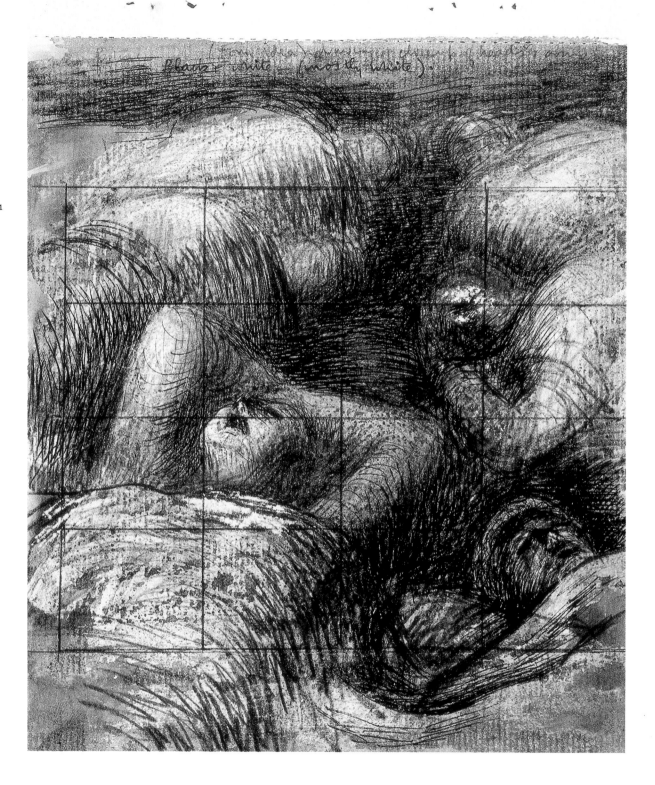

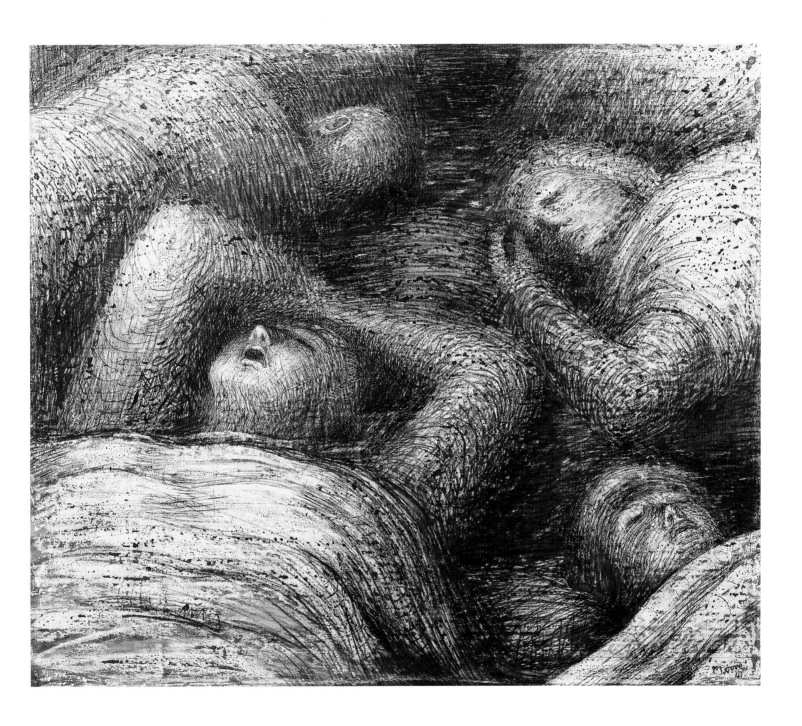

Sleepers

Pink and Green Sleepers (pl.71) from the Tate Gallery, with the *Tube Shelter Perspective*, is one of the best-known of the Shelter Drawings. Moore created at least ten variations on this subject, usually with just two figures, but occasionally, as in *Three Recumbent Figures* (pl.70), including a child.

There are considerable differences in the way the subject is treated, the British Museum preparatory sketch (pl.69) being soft and delicate, while the colours used in the final version are harsher. At the same time, as the variations progress, hands clutching the protecting blanket become more bony

68
Sleeping Figure Studies
1940–41
HMF 1693
pencil, wax crayon, coloured crayon, watercolour wash, pen and ink, gouache
Second Shelter Sketchbook p.68
The Henry Moore Foundation

and claw-like, while mouths fall open in a hideous manner. They seem to be giving out a death rattle, rather than breathing heavily or snoring. *Two Sleepers* from Pallant House, Chichester (pl.72) is especially dramatic – the sleep of the dead, indeed.

From these drawings Moore made several close-up studies of heads. These figures, seen at an angle from below, have always interested art historians. They bear a clear resemblance to certain well-known Renaissance studies in perspective, which Moore admired when he visited Italy on a travelling scholarship in 1925. The foreshortened *Dead Christ* by Mantegna in the Brera Gallery, Milan, is an example, as are the figures of the sleeping apostles in the National Gallery's *Agony in the Garden* by the same artist. Moore himself admitted this connection, referring ruefully to the conflict he had had within himself, between the excitement of discovering Renaissance art, and his strong emotional attachment to the more 'primitive' sculptures of the British Museum. He was to say later that his wartime drawings might well have been the key to the resolution of that conflict. But they were a key to something else as well: Moore's drawings of sleepers were especially appreciated by many of the visitors to WAAC exhibitions at the National Gallery during the war.

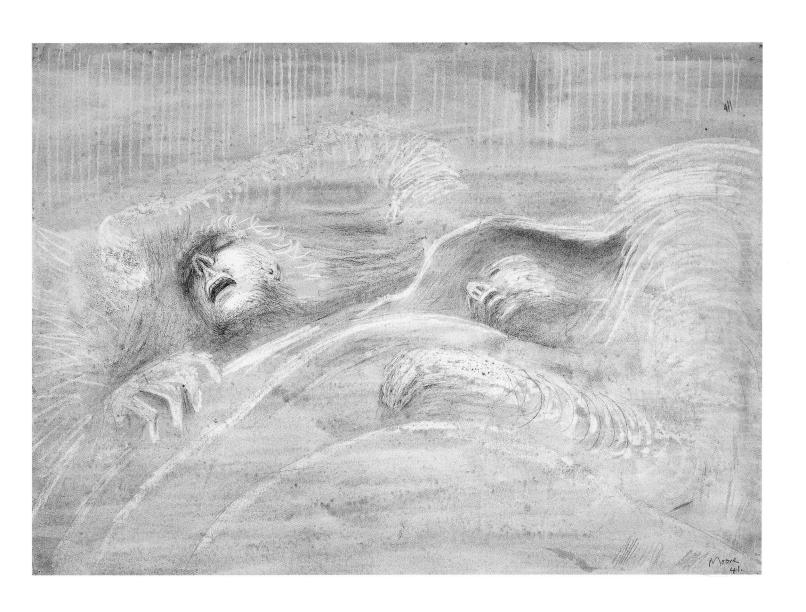

69
**Sketch for 'Pink and
Green Sleepers'** 1941
HMF 1842
pencil, wax crayon,
coloured crayon, wash
394 × 559 mm
The British Museum

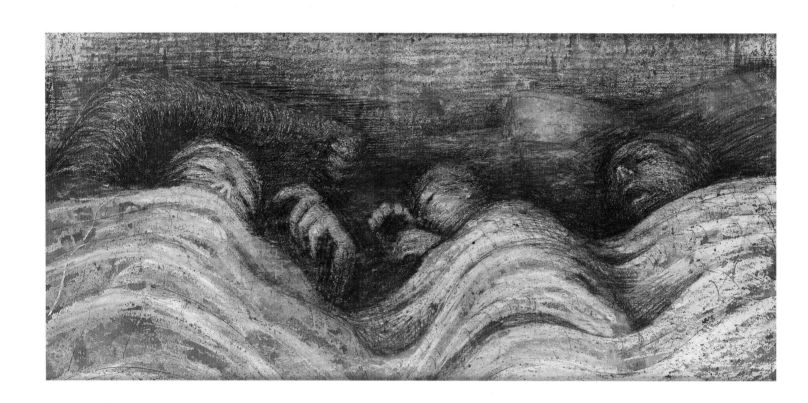

70
**Three Recumbent
Figures** 1940
HMF 1737
pencil, wax crayon,
coloured crayon,
watercolour wash, pen
and ink
242 × 533 mm

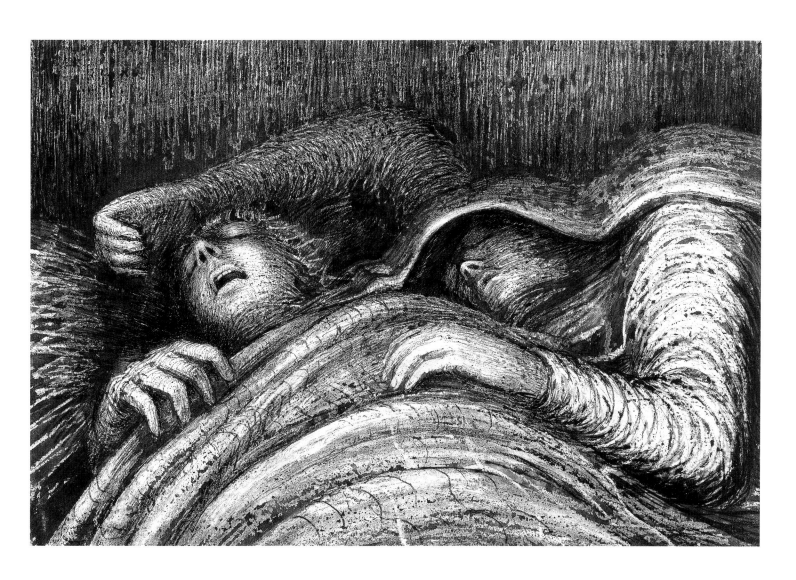

71
**Pink and Green
Sleepers** 1941
HMF 1845
pencil, wax crayon,
coloured crayon, chalk,
watercolour wash, pen
and ink
381 × 559 mm
Tate, London

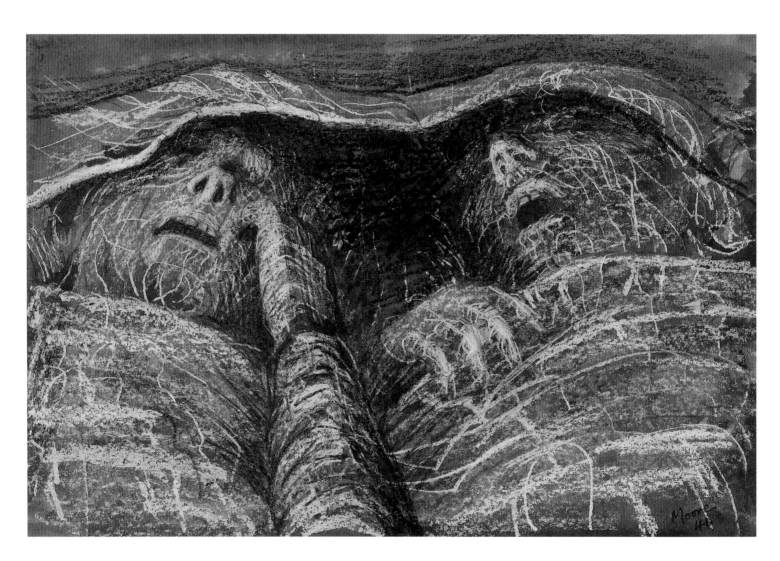

72
Two Sleepers 1941
HMF 1853
pencil, wax crayon,
coloured crayon,
charcoal, watercolour
wash, pen and ink
380 × 556 mm
Pallant House Gallery,
Chichester: The Walter
Hussey Bequest

73
Sleeping Shelterer
1940–41
HMF 1694
pencil, wax crayon,
coloured crayon,
watercolour wash,
gouache
Second Shelter
Sketchbook p.69
The Henry Moore
Foundation

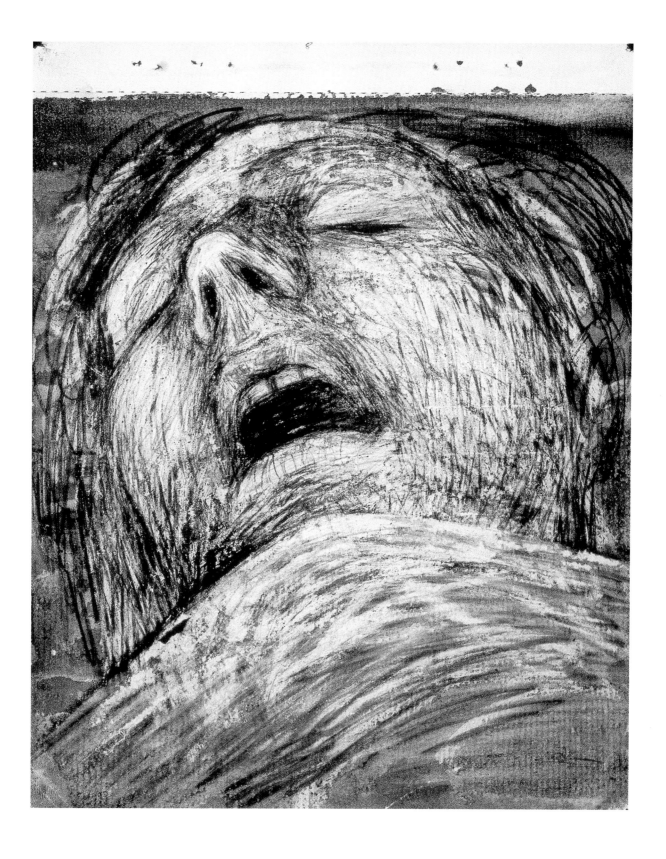

The Fates

The final group of drawings returns to the concept of transformation that informs so much of Moore's work. A bone, a stone or a seashell could be not only the inspiration for a sculpture – the natural object

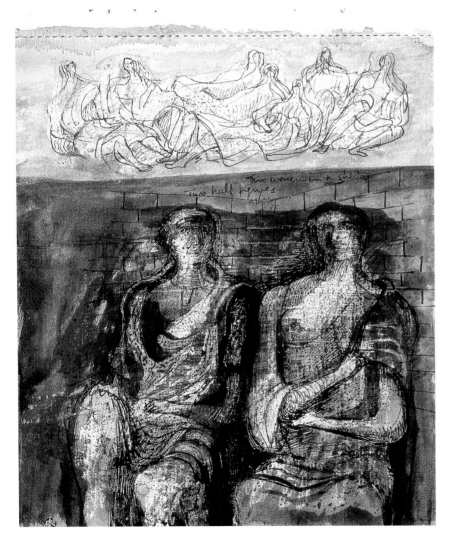

itself could be incorporated into the piece. This process runs right through his work, from drawings based on pebbles made in the 1930s, to the ambiguity of his late monumental figures. In these, at times, the female form becomes interchangeable with the landscape, particularly the reclining figures, many of which owe their origins to scenes in the shelters.

But in the later Shelter Drawings the figures are no longer reclining. They are seated, occasionally still on the ground, but more often on some kind of indeterminate seat or bench. In several of the drawings this seems to take on the function of a throne, since the figures have an air of majesty. This is clear in the sketch *Two Women in a Shelter* (pl.74). But a certain stoicism, a sense of dignity in the face of adversity, is visible in many other Tilbury sketches. In *Two Women in Corner of Shelter* (pl.75) one figure leans trustingly against the other, while the *Two Half-Length Seated Figures* (pl.76) could be sketches for Renaissance figures.

Woman Seated in the Underground from the Tate Gallery (pl.77) bridges two different aspects of the shelter world. Seated against a brick wall, she has an unrelated *Tube Shelter Perspective*, lined with figures, stretching away behind her left shoulder. Obviously weary, but resigned to her situation, she epitomises the patience and endurance of thousands of people who survived with only a minimum of sleep, for weeks on end.

With the sketch *Two Women in a Shelter*, in the large drawing *Shelter Scene: Two Swathed Figures*, from Manchester, and in *Air Raid Shelter: Two Seated Women* from Leeds (pls 82 & 83), the impression of dignity is more pronounced. Looking at these

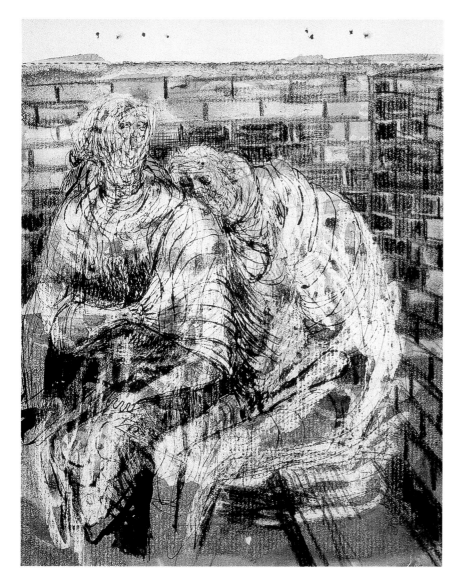

the very different scene in its upper section – two sculptural forms which are rather awkward hybrids. They have upper torsos which are highly abstracted and hollowed out, like Moore's wooden carvings from immediately before the war, combined with figurative lower limbs covered in drapery. Seemingly, even at this stage, Moore felt pulled in different directions by the demands of his subject matter.

Another large finished drawing, *Group of Draped Figures in a Shelter* (pl.81) from the Henry Moore Foundation, ranks with the Leeds and Manchester works for its quiet strength. Though the raids were still continuing there is now an optimism about these figures. As many commentators have said they have ceased to be individuals and have become personages: they have taken on the attributes of prophets, Sybils. They are like the Fates, or the Chorus in a Greek tragedy, standing apart from events but commenting on them. Aware of the violence and destruction taking place in the world above they nevertheless remain removed from it in ways that go beyond the merely physical.

powerful works it is easy to understand why people who had no sympathy for Moore's pre-war modernism felt drawn to him now. In the same category we should place another majestic drawing, the *Two Mothers Holding Children* from the Thyssen-Bornemisza Collection in Madrid (pl.78), where the mother and child on the left face the hooded figure of Death also holding a child, whose face is a skull.

The larger groups of figures, too, have taken on a stature that lifts them above their sordid surroundings. *Study for 'Group of Shelterers during an Air Raid'* (pl.79) is one such group, being the preparatory drawing for the large version from the Art Gallery of Ontario. But the study is interesting for

76
**Two Half-Length Seated
Figures** 1940–41
HMF 1605
pencil, wax crayon,
coloured crayon,
watercolour wash, pen
and ink
First Shelter Sketchbook
p.47
The British Museum

(opposite)
77
**Woman Seated in the
Underground** 1941
HMF 1828
pencil, wax crayon,
coloured crayon,
watercolour, pen and ink
482 × 380 mm
Tate, London

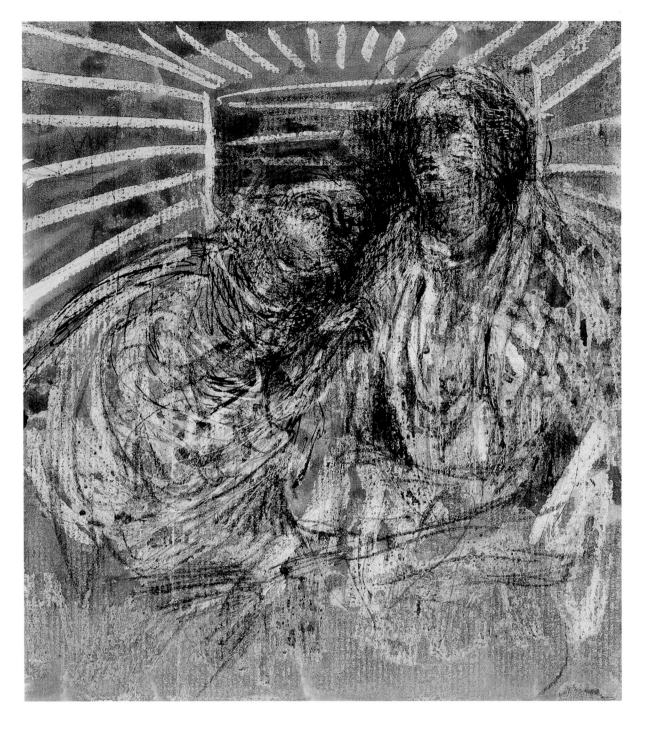

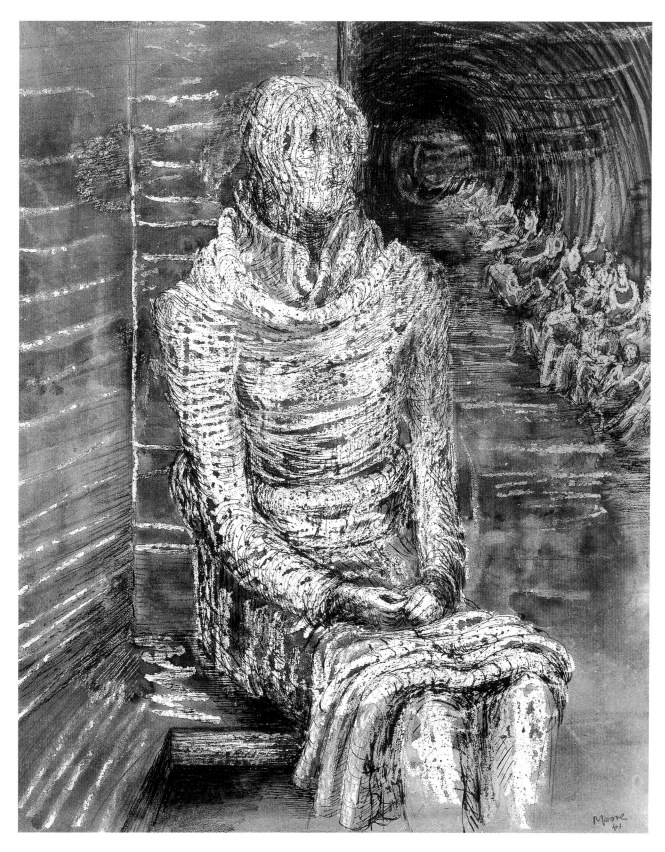

135 The Fates

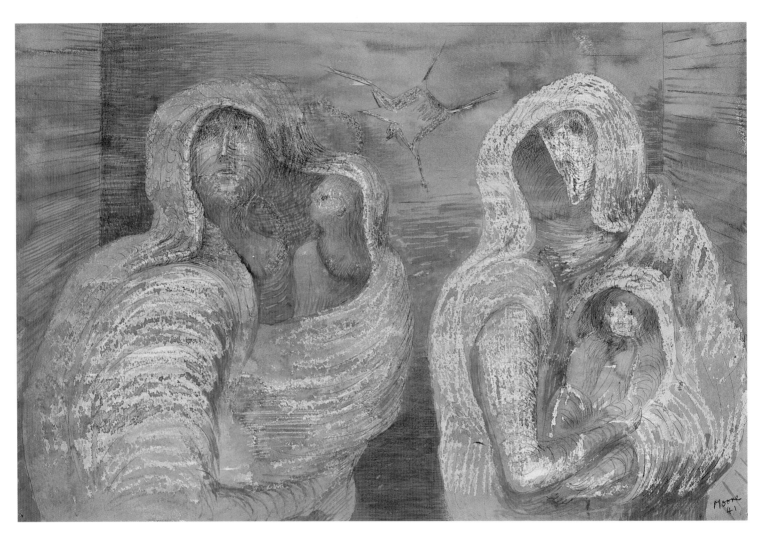

78
**Two Mothers Holding
Children** 1941
HMF 1837
pencil, wax crayon,
coloured crayon,
watercolour wash, pen
and ink
381 × 565 mm
Fundación Colección
Thyssen-Bornemisza,
Madrid

79
Study for 'Group of Shelterers During an Air Raid' 1940–41
HMF 1642
pencil, wax crayon, coloured crayon, watercolour wash, pen and ink
Second Shelter Sketchbook p.17
The Henry Moore Foundation

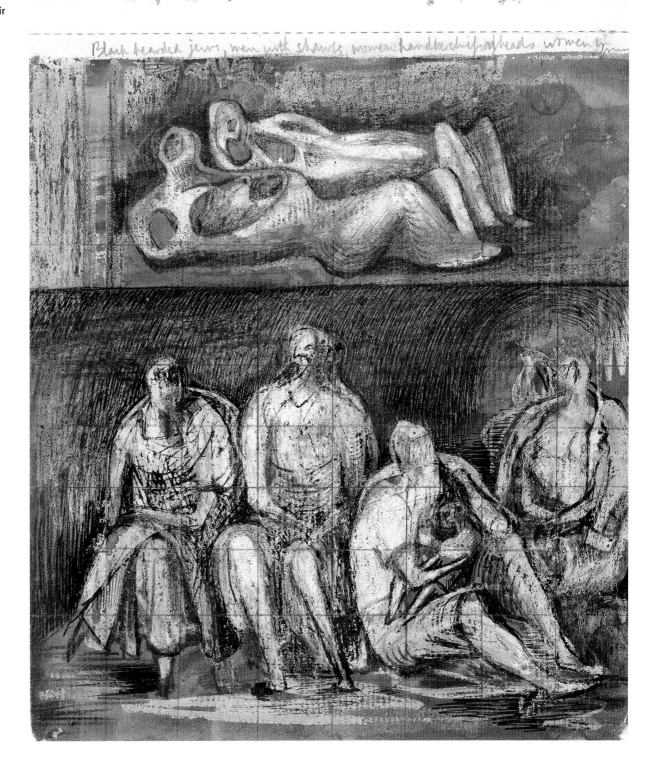

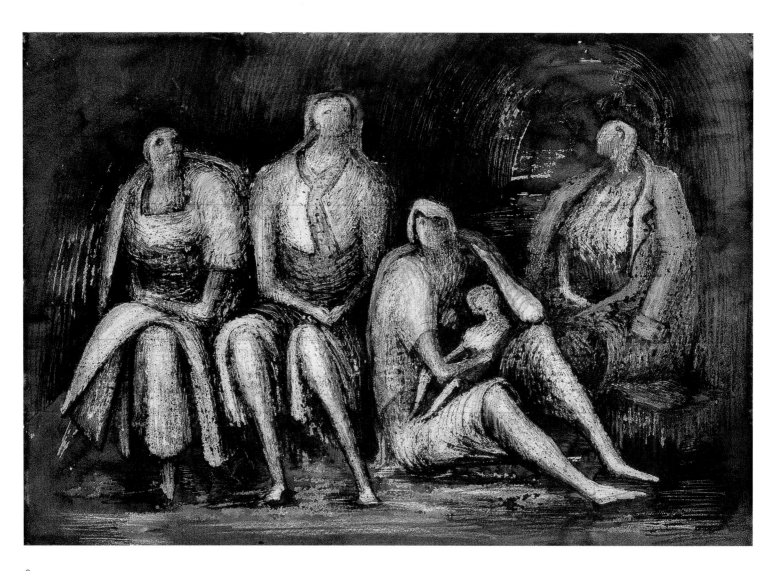

80
**Group of Shelterers
during an Air Raid** 1941
HMF 1808
pencil, wax crayon,
coloured crayon,
watercolour wash, pen
and ink
380 × 555 mm
Art Gallery of Ontario,
Toronto

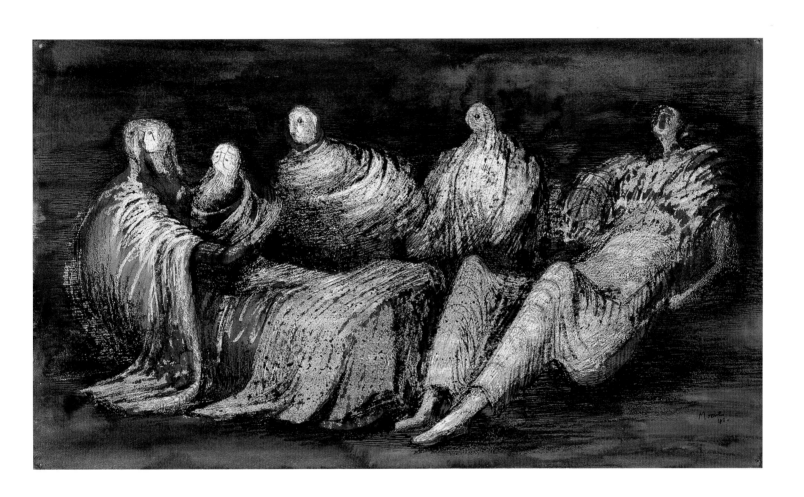

81
**Group of Draped Figures
in a Shelter** 1941
HMF 1807
chalk, wax crayon,
coloured crayon,
watercolour, pen and
ink, gouache
324 × 565 mm
The Henry Moore
Foundation

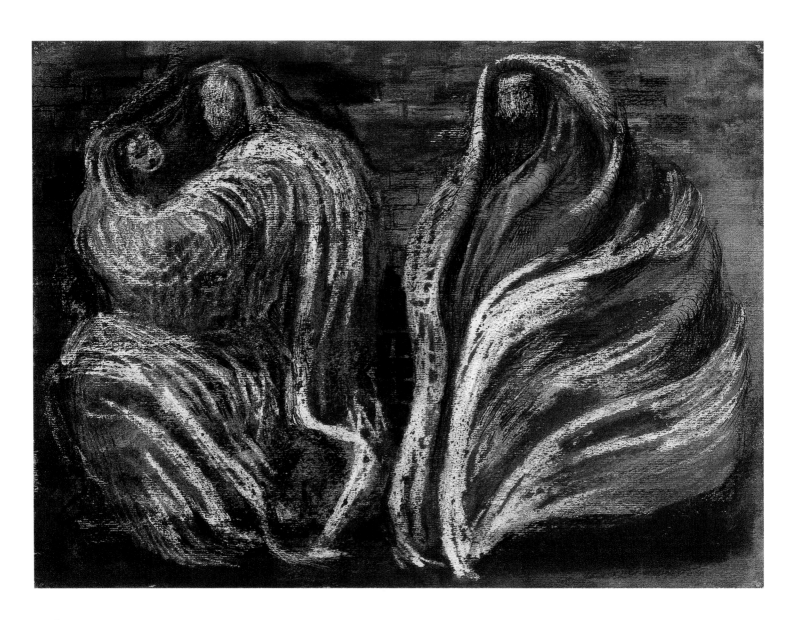

82
**Shelter Scene: Two
Swathed Figures** 1941
HMF 1825
pencil, wax crayon,
coloured crayon,
watercolour wash, pen
and ink
277 × 382 mm
Manchester Art Gallery

(opposite)
83
**Air Raid Shelter: Two
Seated Women** 1940
HMF 1732
pencil, wax crayon,
coloured crayon,
watercolour, pen and ink
432 × 508 mm
Leeds Museums and
Galleries (City Art
Gallery, Leeds)

140 London's War

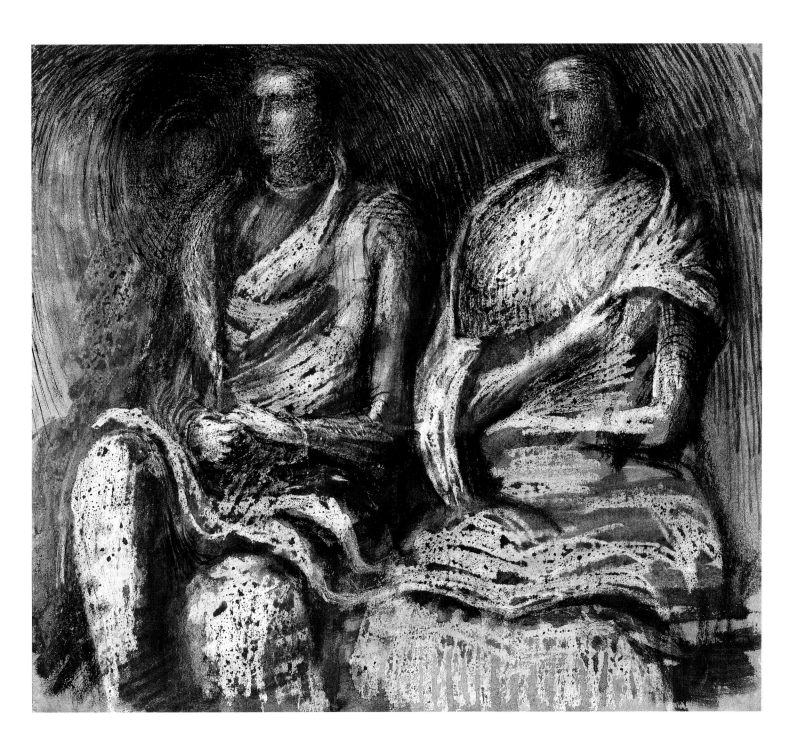

141 The Fates

Endnotes

1 Quoted in James, Philip (ed.), *Henry Moore on Sculpture*, Macdonald, London, 1966, p.218
2 Terms of Reference of the War Artists Advisory Committee were agreed at the first meeting of that committee, held at the National Gallery on 23 November 1939 (see Ministry of Information file GP/72 held at the Imperial War Museum).
3 Calder, Angus, *The Myth of the Blitz*, Jonathan Cape, London, 1991
4 Overy, Richard, *The Battle*, Penguin, London, 2000
5 Newton, Eric, review in *The Sunday Times*, 18 May 1941
6 Anonymous reviewer in *Manchester Guardian*, 10 May 1941
7 Sale, Arthur, *Memories of Moore*, memoir held in the archives of the Henry Moore Foundation
8 Nash, Paul, *Monster Field*, Counterpoint Publications, Oxford, 1946
9 Letter to Alice Gostick, 6 October 1917, Henry Moore Foundation archives
10 Military Operations France and Belgium 1917 vol 3 (Cambrai) HMSO, London, 1948
 Davenport, Captain, *History of the Prince of Wales Own Civil Service Rifles (1st Battalion)*, 1921
 Maude, A. H. (ed.), *The History of the 37th (London) Division, 1914–19*, Amalgamated Press, 1922
 (The second and third of these are extensively quoted in Packer, William – see bibliography)
11 Letter to Arthur Sale, 24 April 1940, Archives of the Department of Art, Imperial War Museum
12 ibid
13 Pile, General Sir Frederick, *Ack-Ack*, Harrap, London, 1949
14 O'Brien, T.H., *Civil Defence*, HMSO, London, 1955
15 Carey, Frances, *A Shelter Sketchbook*, British Museum Publications, London, 1988
16 Letter to Arthur Sale, 10 October 1940, Archives of the Department of Art, Imperial War Museum
17 Carey, Frances, op.cit.
18 James, Philip, op.cit.
19 Letter to Arthur Sale, 22 October 1941
20 Carey, Frances, op.cit.
21 Ministry of Information File GP/55/104 Henry Moore Archives of the Department of Art, Imperial War Museum, London
22 Conversation with the author, 1999
23 'Henry Moore's Shelter drawings look as if he has been excavating in early tombs', *Spectator*, 23 May 1941
24 Greene, Graham, *The Ministry of Fear*, William Heinemann, London, 1943, chapter 3
25 A cast of this mass of bodies was recently displayed in an exhibition shown at the Roundhouse in London, and in Aberdeen, in autumn 2001.

Selected Bibliography

Unpublished sources

1 Official Documents: Public Record Office:

 Ministry of Home Security Files:

 HO 200/1 *Shelter Occupation*
 HO 200/2 *Defence Regulations and Tube Shelter Rules*
 HO 200/3 *Agreement with London Passenger Transport Board*
 HO 205/83 *Tunneling for Shelters: General Guidance to Local Authorities*
 HO 205/179 Prof. J. D. Bernal's paper on Shelter Policy

 Ministry of Information File:

 INF/1/143 *Official War Artists: Functions of the Ministry of Information*

2 Imperial War Museum: Archives of Department of Art:

 IWM:ART 16597 1 *War Artists Archive: Henry Moore: Letters to Arthur Sale*

 Ministry of Information Files:

 GP/46 A and B *Employment of Artists in Wartime*
 GP/55/104 *Henry Moore*
 GP/72 *War Artists Advisory Committee*

3 Henry Moore Foundation Archives:

 Henry Moore: Letters to Alice Gostick

Published Sources

4 Official Publications:

 The Battle of Britain, HMSO, London, 1941
 Civil Defence, T. H. O'Brien, HMSO, London, 1955
 The Defence of the United Kingdom, Basil Collier, HMSO, London, 1957
 Fire over London: The Story of the London Fire Service 1940–41, HMSO, London, 1942
 Front Line, Ministry of Information, London, 1942
 Problems of Social Policy, R. M. Titmuss, HMSO, London, 1950
 Roof Over Britain, Ministry of Information, London, 1943

Publications on Henry Moore

5 Books and Catalogues dealing specifically with the Shelter Drawings:

 Andrews, Julian and Garrould, Ann, *Henry Moore: Shelter and Coalmine Drawings*, exh.cat., DDR Ministry of Culture and The British Council, Berlin, 1984
 Carey, Frances, *A Shelter Sketchbook*, British Museum Publications, London, 1988
 Carey, Frances, *Henry Moore: The Shelter Drawings*, British Museum Society Bulletin, London, 1988
 Darracott, Joseph, *Henry Moore: War Drawings*, Imperial War Museum, London, 1976
 Flemming, Hans Theodor, *Henry Moore: Katakomben*, Piper Verlag, Munich, 1956
 Mitchinson, David and Feldman Bennet, Anita, *Henry Moore: War and Utility*, exh.cat., Henry Moore Foundation, 2001
 Petermann, E. and Melville, Robert, *Die Shelterzeichnungen des Henry Moore*, exh.cat., Staatsgalerie Stuttgart, 1967
 n.a., *Shelter Sketch Book*, Editions Poetry, London, 1945
 n.a., *Henry Moore: Shelter Sketch Book*, Marlborough, London and Rembrandt Verlag, Berlin, 1967

6 General works on Henry Moore, which also refer to the Shelter Drawings:

 Berthoud, Roger, *The Life of Henry Moore*, Faber & Faber, London, 1987
 Clark, Kenneth, *Henry Moore Drawings*, Thames and Hudson, London, 1974
 Garrould, Ann, *Henry Moore Drawings*, Thames and Hudson, London, 1988
 Garrould, Ann (ed.), *Henry Moore: Complete Drawings, vol.2, 1930–9*, Henry Moore Foundation and Lund Humphries, London, 1998
 Garrould, Ann (ed.), *Henry Moore: Complete Drawings, vol.3, 1940–9*, Henry Moore Foundation and Lund Humphries, London, 2001
 Grigson, Geoffrey, *Henry Moore*, Penguin Modern Painters, Penguin Books, Harmondsworth, Middlesex, 1943
 James, Philip (ed.), *Henry Moore on Sculpture*, Macdonald, London, 1966

Kosinski, Dorothy (ed.), *Henry Moore: Sculpting the 20th Century*, Dallas Museum of Art, Dallas, Texas, 2001

Mitchinson, David and Andrews, Julian, *Celebrating Moore*, Henry Moore Foundation and Lund Humphries, London, 1998

Packer, William and Levine, Gemma, *Henry Moore: An Illustrated Biography*, Weidenfeld & Nicholson, London, 1985

Read, Herbert, *Henry Moore*, Thames and Hudson, London, 1964

Wilkinson, Alan, *The Drawings of Henry Moore*, exh.cat., Tate Gallery, London, 1978

Wilkinson, Alan, *The Moore Collection in the Art Gallery of Ontario*, Art Gallery of Ontario, Ontario, 1979

The Battle of Britain and the Blitz

7 General Studies:

Air Raids, introduction by Stephen Spender, Oxford University Press, 1943

Blitz, introduction by J. B. Morton, Oxford University Press, London, 1942

Calder, Angus, *The People's War*, Jonathan Cape, London, 1969

Calder, Angus, *The Myth of the Blitz*, Jonathan Cape, London, 1991

Calder, Angus and Sheridan, Dina, *Speak for Yourself: A Mass Observation Anthology*, Jonathan Cape, London, 1984

Clark, Ronald, *The Role of the Bomber*, Sidgwick and Jackson, London, 1977

Collier, Richard, *1940: The World in Flames*, Penguin, Harmondsworth, Middlesex, 1980

Conyers-Nesbitt, Roy, *The Battle of Britain*, Sutton Publishing, Stroud, Gloucestershire, 2000

Fitzgibbon, Constantine, *The Blitz*, Allan Wingate, London, 1957

Gregg, John, *Shelter of the Tubes*, Capital, London, 2001

Harrison, Tom, *Living through the Blitz*, Collins, London, 1976

Hecks, Karl, *Bombing 1939–45*, Robert Hale, London, 1990

Marwick, Arthur, *The Home Front*, Thames and Hudson, London, 1976

Overy, Richard, *The Battle*, Penguin, London, 2000

Pile, Gen. Sir Frederick, *Ack-Ack*, Harrap, London, 1949

Ray, John, *The Night Blitz*, Arms and Armour, London, 1996

Seaborne, Mike, *Shelters*, Dirk Nishen Publishing, London, 1988

Westall, Robert, *Children of the Blitz*, Penguin, London, 1987

Whiting, Charles, *Britain under Fire*, Leo Cooper, Pen and Sword Books, Barnsley, 1999

Ziegler, Philip, *London at War: 1939–1945*, Sinclair Stevenson, London, 1995

8 Biography, Diaries and Memoirs:

Farson, Negley, *Bomber's Moon*, Gollancz, London, 1941

Henrey, Mrs Robert, *London under Fire 1939–1945*, Dent, London, 1969

Royde-Smith, Naomi, *Outside Information*, Macmillan, London, 1941

Strachey, John, *Post 'D'*, Gollancz, London, 1941

9 World War II Art and Artists:

Bato, Joseph, *Defiant City*, Gollancz, London, 1942

Foot, M. R. D., *Art and War*, Headline/IWM, London, 1990

Hall, Charles, *Paul Nash: Aerial Creatures*, exh.cat., Imperial War Museum, London, 1997

Harries, Meirion and Susie, *The War Artists*, Michael Joseph, London, 1983

Newton, Eric, *War through Artists' Eyes*, John Murray, London, 1945

Ross, Alan, *Colours of War*, Jonathan Cape, London, 1983

Stansky, Peter and Abrahams, William, *London's Burning*, Constable, London, 1994

10 Fiction:

Greene, Graham, *The Ministry of Fear*, Heinemann, London, 1943